ALL POSSIBLE WORLDS

PHOTOGRAPHS BY DOUGLAS D. PRINCE

ESSAY BY ROBERT R. CRAVEN

EDITED AND PREFACE BY BARRY W. ANDERSEN

An exhibition at Northern Kentucky University

March 3 through March 31, 2000

Touring nationally

Northern Kentucky University Press, Highland Heights

All Possible Worlds

Northern Kentucky University Press
Highland Heights, Kentucky 41099
Photographs ©1999 by Douglas D. Prince
Essay ©1999 by Robert R. Craven
All other rights reserved
©Northern Kentucky University

Library of Congress Catalog No. 99-63536

ISBN 0-9672678-0-3 (hardcover)
ISBN 0-9672678-1-1 (paperback)
104 pages, 8.5 x 11 inches

All Possible Worlds

PREFACE

I first met Doug when I was a graduate student at the University of Florida in 1973. The youngest of a strong photo faculty trio with Todd Walker and Jerry Uelsmann, Doug was a teacher with high standards, a very prolific picture maker, and a fine racquetball player. Our relationship continued after graduate school. Doug taught a year at N.K.U. as a sabbatical replacement for me, and I came to know him better as a colleague, an artist, and a friend.

In the best of all possible worlds, the photographs of Doug Prince would have come to your attention long ago. Although his photographs have appeared in numerous publications and prestigious periodicals, the vagaries of publishing decisions have left this fine body of work as yet unpublished. I had for years expected a monograph to be published of his work, but none had come to be. This project began in 1996, when a grant application to support the publication and exhibition of under-recognized American artists crossed my desk. I contacted Doug and forged ahead with the task of putting together a major exhibition of his work with an accompanying catalog. This catalog is a record of the exhibition at Northern Kentucky University and will accompany the exhibition as it travels. It serves to honor the ongoing accomplishments of Doug Prince in bringing these pictures into the world.

Our time and culture have so deeply imbedded in us the inherent believability of the photograph, that while we may suspect that the events depicted in these pictures did not occur in the world as we know it, we are nevertheless captivated by the possibility that they may have. One might in fact stumble on a cryptic piece of geometry left in the sand of an idyllic seashore, watch a man tend a garden only slightly removed from Eden, or overlook a pristine white calf safe in a world with no enemies. We may chuckle at the wiry white dog in front of a carnival booth extolling giant Korean rats. We may perhaps, again, inhale deeply the innocence of childhood.

In the best of all possible worlds, these photographs might lead you to the poetic truth that amongst all the chaos of the world, in our hearts this vision of mystery, irony, and wonder finds resonance.

Barry Andersen, 1999

About the author:

Barry Andersen is a Professor of Art at Northern Kentucky University where he has taught photography since 1975.

ACKNOWLEDGEMENTS

This catalog and exhibition were made possible through the generous support of Thomas R. Schiff, Barbara G. Hilton, matching support from Northern Kentucky University's Office of Research, Grants and Contracts, and a Faculty Project Grant from Northern Kentucky University.

Special thanks go to the many people who assisted in the production and realization of this project: Cliff Shisler, Director of Research, Grants, and Contracts at NKU for his encouragement; Barbara Houghton for web page production and general sage advice; Kathy Dawn, George Hadesty, Jim Parker, Bob Grout, Jeanne Linville, JoAnn Fincken, and Bonnie Smith in Printing Services at NKU for their patience and commitment to excellence; Joe Hamilton at Stevenson Color and Jeff Siereveld at Mad Macs for technical assistance; Jerry Uelsmann of the University of Florida, Roger Bruce of the George Eastman House, and Bart Parker of the University of Rhode Island for their enthusiastic support; Robert Johnson at LPK Design for the elegant design of the catalog.

I am grateful to my colleagues and many students at NKU whose support, curiosity, and challenges over the years have enriched my academic life. Doug Prince, with his easy manner and editorial help, made this project much easier. A special thanks to my wife Diane Kruer and son Ian Andersen for their patience during this adventure and for the great gift of family.

Barry Andersen
Fort Thomas, Kentucky
1999

My first expression of gratitude must go to Barry Andersen. Without his hard work and dedication, this book and exhibition project would never have been realized. The titles of editor and curator do not reflect the true extent of Barry's role in this undertaking. He is also responsible for initiating the proposal and organizing the funding. Barry has given most generously of his time and resourcefulness in all the multitudinous aspects of this desktop publishing project. He has approached this undertaking with the same passion and commitment to excellence that he gives to his teaching and photography. I feel very fortunate to have a friend like Barry who believes in my work and is committed to making it available to a wider audience

Let me also acknowledge Robert R. Craven for sharing his insights and perspectives on the images and Rosemond Wolf Purcell for helping me appreciate the placement of pictures in a book format. I would also like to thank Lysa James for her poetry and Ron Gehrmann for his advise on fonts.

Many people have contributed and influenced my vision as a photographer. To all these people I would like to acknowledge my debt of gratitude. My parents, Don and Marge Prince, helped me to develop an early appreciation of nature and allowed me to grow up with my creative spirit intact. Many teachers and many students have inspired me throughout my career as a photographer. Special consideration must be given to John Schulze and Ralph Kopple at the University of Iowa who shared their personal wisdom and taught me to see photographically. My children, Brice, Brian, Case, and Francesca have allowed me to observe and photograph private moments of their childhoods. These were special and close times between us. Barbara Hilton has been my supportive, understanding, and encouraging partner during this project, as in life. Thank you.

Doug Prince
Portsmouth, New Hampshire,
1999

TREADING THE BRINK:
THE PHOTOGRAPHIC BLENDS OF DOUG PRINCE

by Robert R. Craven

Thus did I by the water's brink
Another World beneath me think;
And while the lofty spacious Skies
Reversed there abused my Eyes,
 I fancied other Feet
 Came mine to touch and meet;
As by some Puddle I did play
Another World within it lay.

From Thomas Traherne
"Shadows in the Water" (17th century)

Seeing only one sight at a time, we must make connections to give what we see meaning in context. Everything reminds us of something else, and it's in that connection between what we see now and what we saw then that meanings arise. In dreams, we sometimes compound times and places, combining memories that in waking hours remain distinct. Such connections, and the mysterious, evanescent meanings they create, are at the heart of Doug Prince's blended photographs.

From his black–and–white archives, Prince selects pairs of images that connect — visually, poetically, and psychologically, following their own inexplicable, organic logic. Blended with great craft into a single print, they are readily perceived as direct photographs of things that could but probably did not happen. Thus two or more images, each carrying meaning for the artist (and, by virtue of his artistry for the viewer as well) become one. The blend signifies far more than the sum of its parts, for in addition to the visual and other meanings of each constituent, we are struck by the immediacy and vitality of the implied comparisons and contrasts — we witness, and participate in, the moment of meaning. Moreover, we have the luxury of contemplation, for unlike the momentary connections among everyday perceptions, these images, with their richly ambiguous

relationships, resonate in time.

An exaggerated perspective thrusts the foreground image toward the picture plane while drawing the viewers attention back into the contextual field. Somewhere in between is the blend — metaphorically an invisible passage between times and places. Like the brink between what we see and the

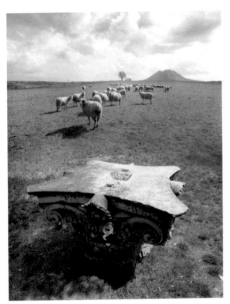

meaning of what we see, it defies definition yet invites discovery. The perspective is powerful, both visually and in its poetic connection to the depths of time and consequent implications of birth, growth, death, and decay.

The subjects too — children, broken monuments, moments of atmospheric revelation — are pointedly temporal. The results are compelling.

In *Corinthian Capital and Sheep*, for example, a detached capital lies in the extreme foreground of a grassy plain. A flock of sheep trails off into the background, leading our eyes to a barren horizon punctuated by a bare tree and lone hill. Combined with an evocative tonal

range, the effect is a bit disturbing, an Arcadia within the realm of possibility, yet reminiscent of a surreal mindscape. Tragic overtones are tinged with the Absurd: if the sheep could speak, what Ozymandian tale would they tell? Or are they simply confused?

Perspective draws us into ironies of situation. A bather wades as lightning cracks the sky behind her. A curl of sea-foam laps the base of a Roman fountain of Neptune. A startled deer stares at us from a room bristling with trophy heads. A baby carriage, covered in mosquito netting, sits abandoned on a beach as a squall darkens the sea behind.

The ironies may be unsettling, even frightening; but as with all irony, they have

comic potential as well. Even the darkest of these visions is informed by the artist's wit. When the subject is lighter, the effect can be quite droll. A young mother, kneeling on a plaid picnic blanket, bottle-feeds her baby as a gentle cow peers inquisitively

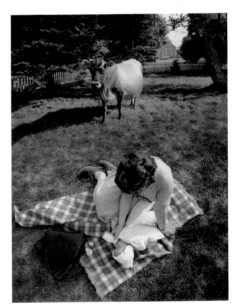

over her shoulder. We, too, are caught up in

a moment of bovine wonder.

Such surface relationships, however striking, are enriched by visual connections

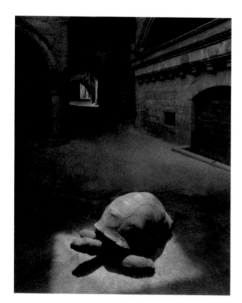

that imply meanings of their own, sometimes congruent with the narrative, sometimes richly contrapuntal.

Form, texture, and tonality all add to the equation.

In one photograph a shaft of light defines the arched shell of a tortoise; behind, a street disappears into a darkness of Romanesque arches and barrel vaults. Ancient yet evolutionary, lumbering towards the future yet planted in the past, both fore– and background share something eternal in their formal affinity.

On the other hand, formal structures may diverge, creating tensions that intensify the narrative. A little boy lies on the surface of a deserted road, face to face with a rattlesnake, his slight body echoing the lazy "s" of the flattened serpent. The road, inexorably straight, pulls us far into the distance, where it finally makes a slight turn to the right and disappears into the undulating hills at the horizon. Here,

disparities of narration are supported by disparities of form.

The black–and–white medium facilitates blending, but it also works metaphorically, as if to say that some relation-ships are beneath the surface — if not subterranean, then at least subtle. The denial of color heightens other visual markers and the connections they imply. Comparisons and contrasts of texture, for example, can lead to some intriguing effects within the already–complex contexts of blended images.

Sand, stone, and earth are staples of Prince's foreground settings. Sometimes marked by human hands, sometimes in the

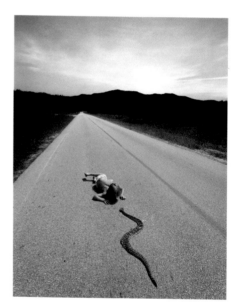

process of geologic evolution, their surfaces carry both narrative and visual texture. Contrasts of hardness and malleability, flatness and incision, smooth-ness and graininess, all work to set up tensions that carry across that invisible line into the "other" context of the background. In one striking example two children dig in sand whose pocketed surface is dramatically

revealed by parallel lighting. One peers out of his hole; the other, on all fours, is still burrowing, and the smooth muscles of his arched back contrast with the distressed ground beneath him. In the context of a beach at sunset, the image would be comprehensible. But where are they

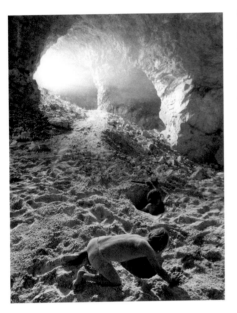

digging? We are drawn insistently back to the mouth of a cave, from whose depths a light shines through the dust, silhouetting the arch of its entranceway, and, seemingly, illuminating the sand and children before us. Everywhere the contrasts in light surprise and confound us. Both literally and figuratively, we must dig for the truth of the image. Is it in the light at the end of the tunnel? Is it below the surface of the sand?

Water too affords the artist many opportunities to mix narration, visual expression and poetic connotations. In one photograph, two children walk ankle deep, through a culvert that tunnels below a terraced garden of fountains. Like the subterranean connections between the

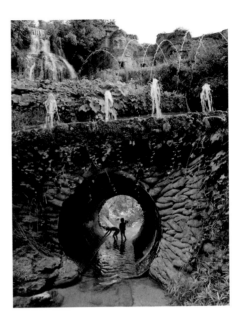

images themselves, the tunnel is rich in possibilities. The links between surface and depths are surely there, but they are hidden, like the connections between the free flowing fountains of consciousness and the hidden conduits of memory.

Like the images in these photographs, water has both surface and depth. We see through it to the world below even as it reflects the world above. Several of the photographs involve swimmers — snorkeling in the fountain of a Roman river-god; gliding away from an abandoned canoe; clambering ashore in a jungle of vines. But the richest image in this group, and perhaps of the whole collection, is *Self-Portrait as Dreaming Man.* Here, sky, land, water and its depths connect in a nocturne of tonality and psycho–symbolism, intensified through composition and formal relationships. The strong horizontal line at land's edge vies with the vertical orientation of the central images. Top and bottom reflect one another, not only in tonal range but in the several

arches that define the image's composition. The moon, reflected in lens flares, seems to emanate from the face below. The face is above water; the body sinks beneath, to yet another level of depth. In the far distance, on the horizon and just at the vertical axis, a house perches on a little hill — impossibly far away and precarious in its point of balance. At the water's brink the weeds seem to float in air. The distant hills seemingly dip into the little gully in mid–ground, condensing the perspective and further compounding the image's sense of other–worldliness. We feel as if we have intruded upon a dream in progress, or

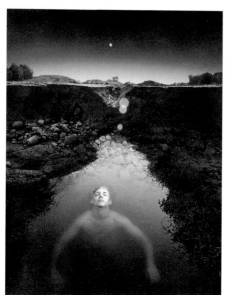

are witnessing meaning-in-the-making, as the worlds above and below join in a moment of transcendence.

All this takes place in two dimensions, and the implications of further dimension-ality add to the mystery — we are drawn not only towards an illusional horizon but through levels of time. But what if the image itself were three-dimensional?

The answer is found in a series of

what the artist calls photo–sculptures or, informally, "boxes." Like the blends, the sculptures take full advantage of the medium's metaphorical implications. A series of images are printed on translucent film, sandwiched between successive layers of plexiglass, and mounted in a plexiglass viewing box. Lighted from behind, the images take on a 3-D look reminiscent of a stereoscope. The difference, however, is that the parallax here is more complex. There is real depth, but it's a depth of successive layers of flatness, each with its own three-dimensional illusion. The boxes are small — about six inches square and a couple of inches deep. The viewer must look closely, and that too becomes part of the metaphor.

Whereas the 2–D blends place disparate images next to one another, the 3–D boxes layer them, and we literally see through the surface image to the regions beyond.

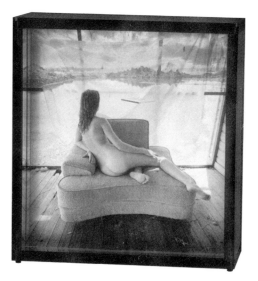

As with the blends, the sculptures create possible but slightly improbable

worlds. In *Odalisque (After L. B.)*, for example, the classical nude faces away from us, towards a gauze-covered window, beyond which a calm lake leads our eye to a horizon punctuated with ambiguous forms. The gauze, like the overlaid images themselves, reminds us of layered memory and the ambiguities of perception.

Perhaps the most mysterious of the photo–sculptures, and one of the most

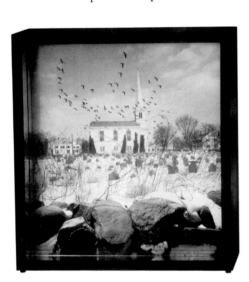

evocative in the entire collection, is *Return of the Flock*. Here, we peer across a snow-covered stone wall and graveyard to a colonial village, where white-clapboard homes are separated by bare trees and dominated by a white church whose steeple raises our eyes towards the white clouds above. The gravestones, picking up the middle tones of the foreground, pull us insistently to a seeming horizon; but where our eyes might expect sky we see instead the village and church, which pull us yet farther into the distance. By virtue of the medium, the intervening air takes on a 3–D

"presence," and so the eerie stage is set. A flock of geese, wings silhouetted in black, swirls loosely above the cemetery, connecting sky, church, and, by their visual analogy, the gravestones below. Like the chimney swifts in Bosch's Garden of Earthly Delights, they suggest something unsettling and unnameable, something fleeting between the sky and the grave.

In Doug Prince's photo-sculptures and blended images we find the sensibility of a Metaphysical poet who creates other worlds from the disparate elements around us. The difference is that in Prince's creations those poetic elements are made visible, an invitation to see the world in a new way, to make new connections.

The Mind, that Ocean where each kind
Does straight its own resemblance find:
Yet it creates, transcending these,
Far other Worlds, and other Seas.

From Andrew Marvell,
The Garden (17th century)

About the author:

Robert R. Craven is Professor of English and Humanities at New Hampshire College. He is a regional art review editor for the magazine Art New England, and his many publications include a two-volume encyclopedia of symphony orchestras around the world.

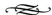

"But in the end, of course, something eluded

him. That he would die, and that his children

would die, that everyone was subject to the laws

of entropy, no longer bothered him. He had

no desire to live forever. If life isn't meaningful

now, in the present moment, it won't become

meaningful by being prolonged indefinitely.

Death, in fact, is a condition of meaning.

Without it, human beings, like the Greek gods,

would make no significant choices, confront

no limitations."

Robert Hellenga
The Fall of the Sparrow

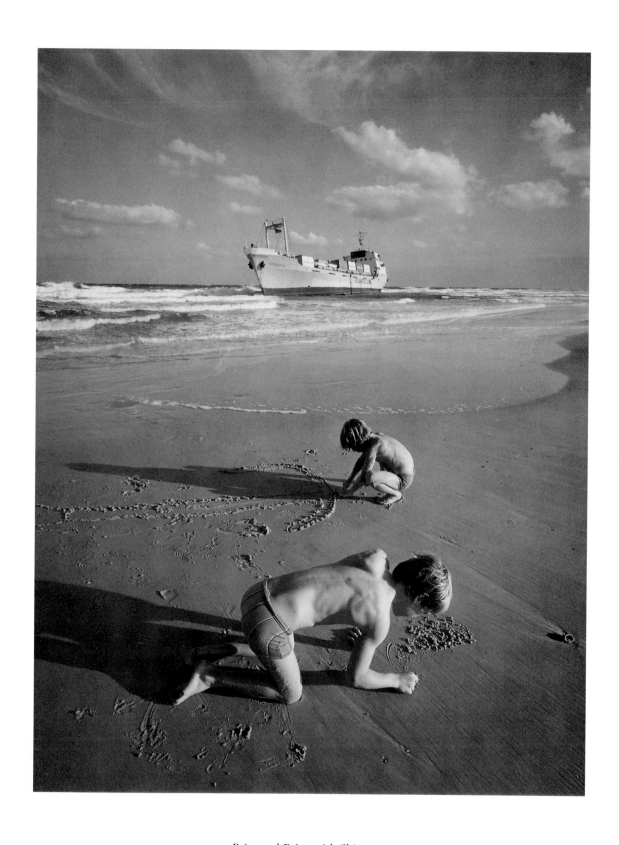

Brice and Brian with Ship, 1979

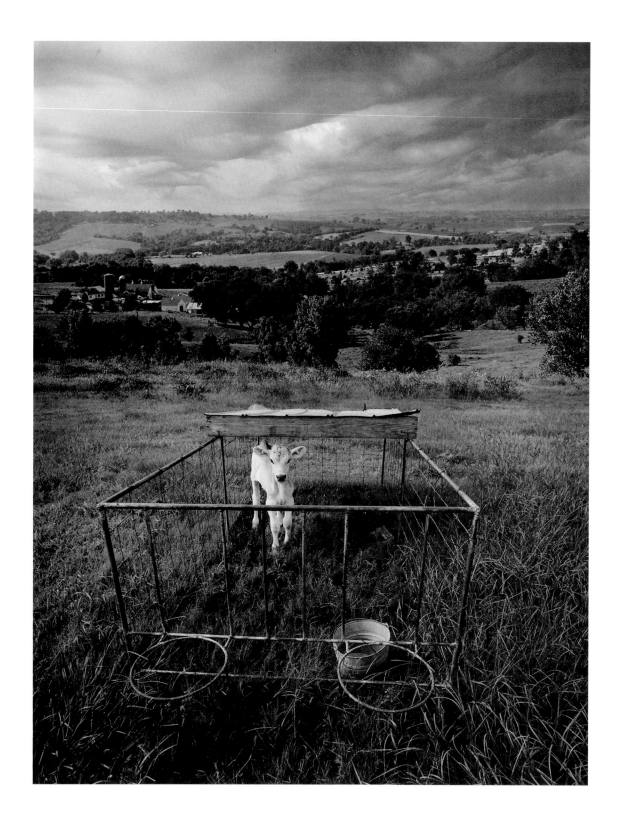

White Calf in Pen, 1980

Case under Cityscape, 1996

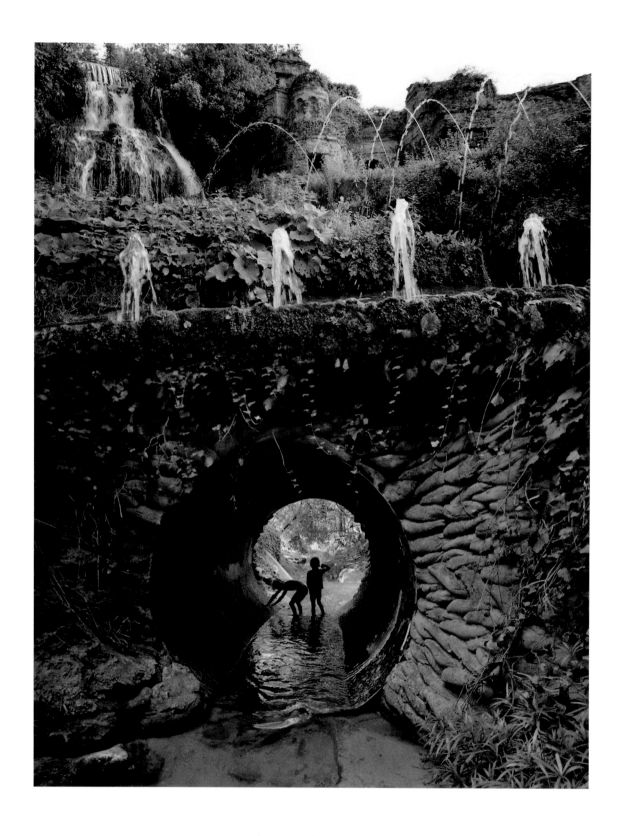

Brice and Brian under Fountains, 1993

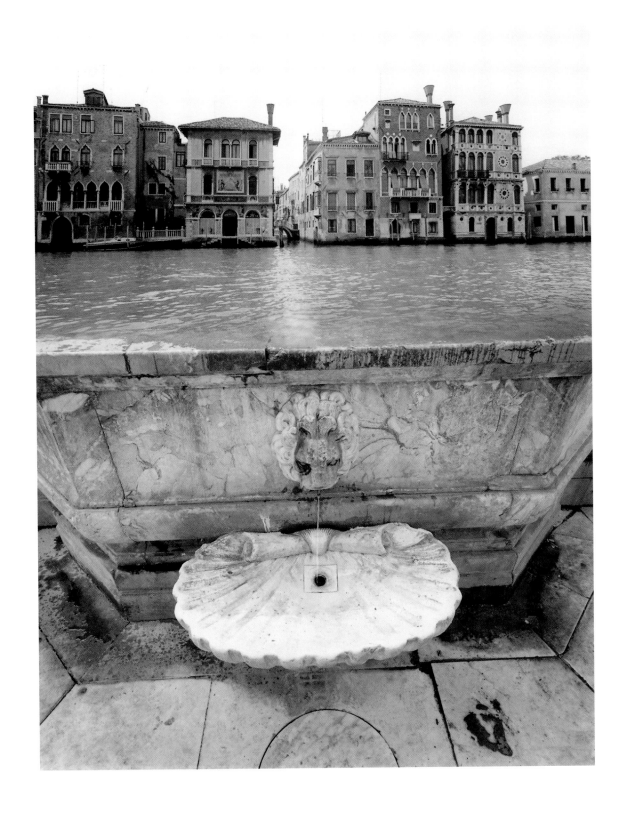

Fountain and Canal, 1993

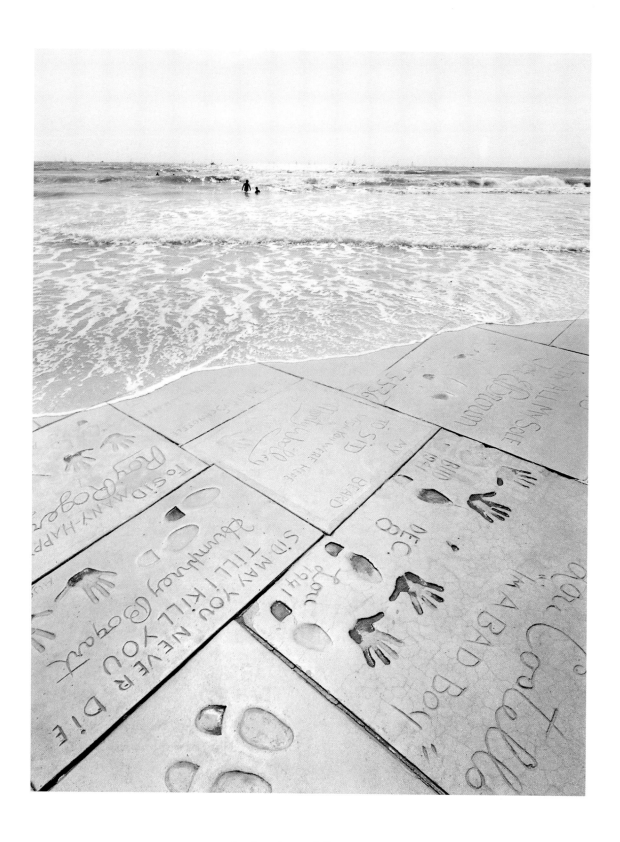

Star Imprints and Ocean, 1992

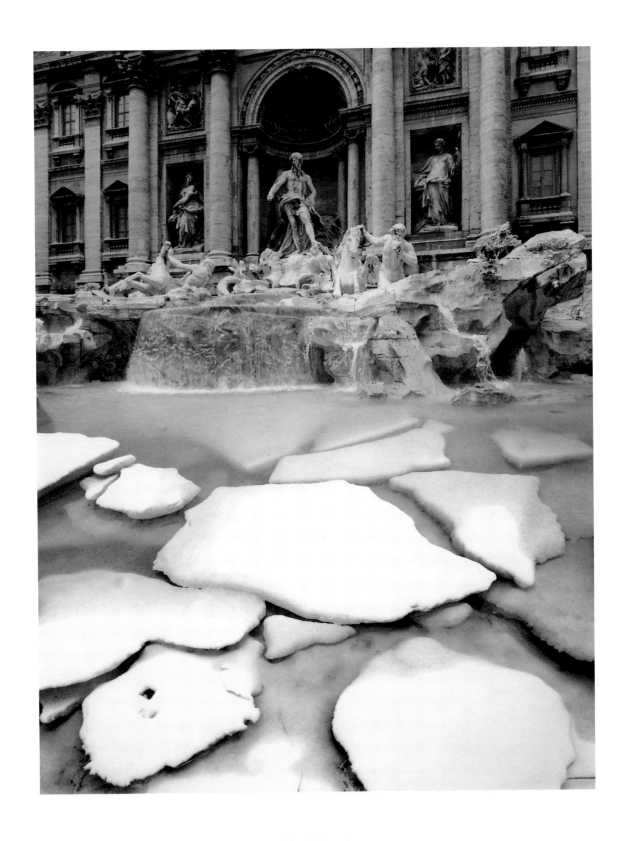

Ice in Trevi Fountain, 1992

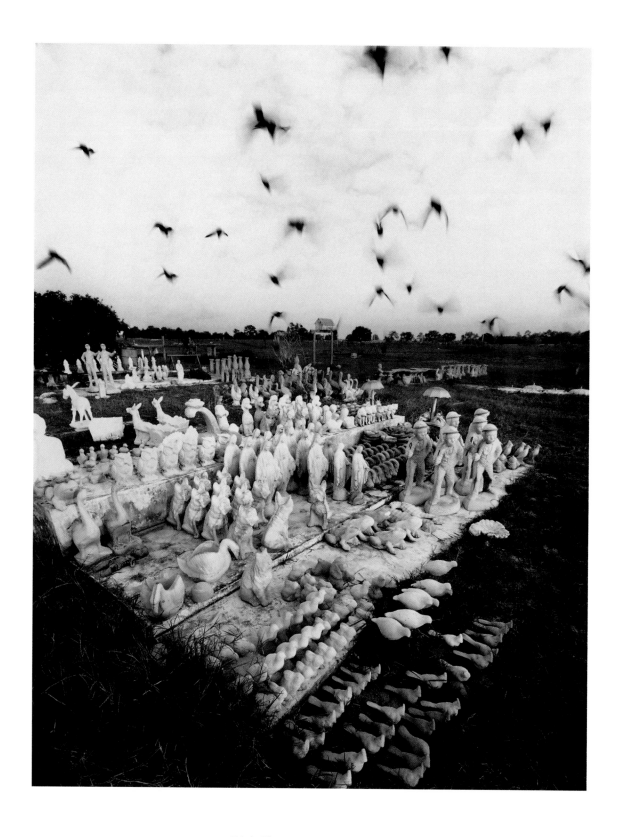

Birds Flying over Statues, 1979

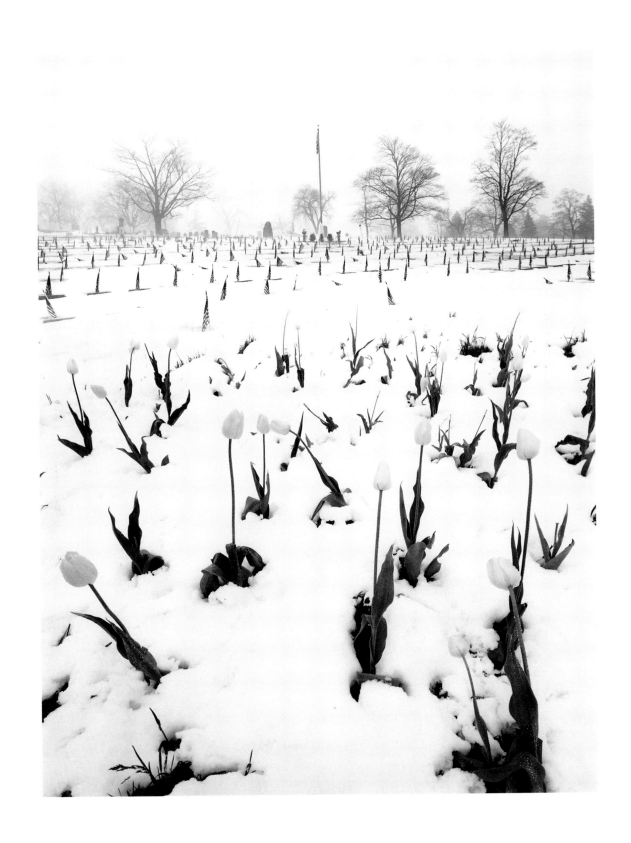

Tulips and Flags, 1979

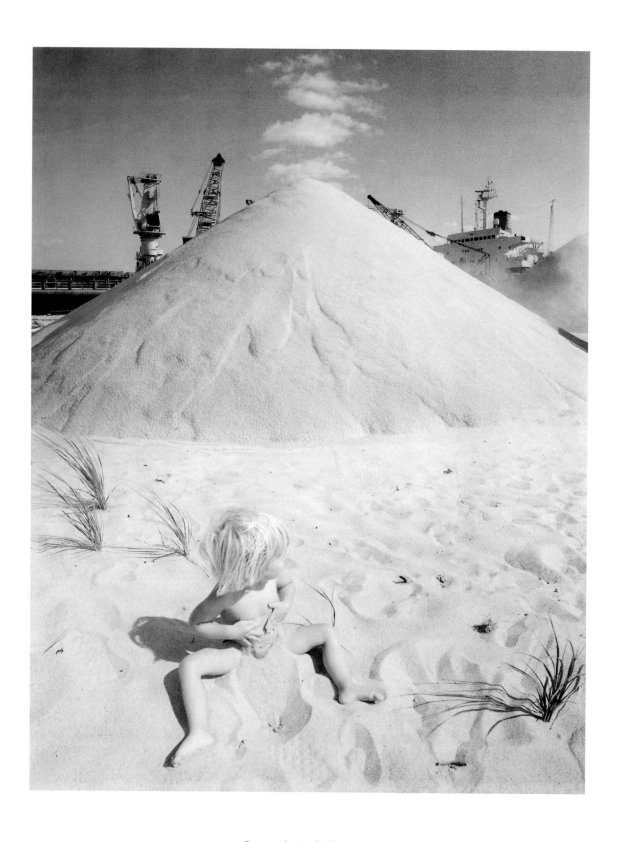

Case with Sand Pile, 1994

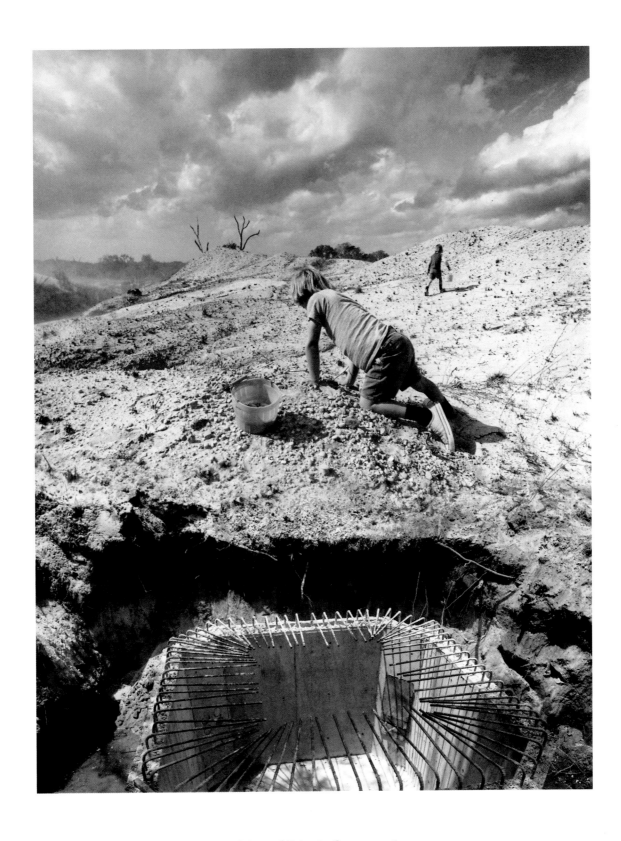

Brice and Brian in Quarry, 1996

LIGHT INTO EARTH

Children are saplings hungry for light
But the veins of their light-seeking leaves
Run like rivers into their limbs, into their heart-holding trunks,
Down into roots, are nourished by water, by dirt,
By the flesh of the ancestors turned to earth.

They are the weed trees that burst into life,
The miracle so common no one observes,
The ordinary turning toward light, the willing
Absorption of dirt, crushed stone
From which all our bones are born.

Lysa James

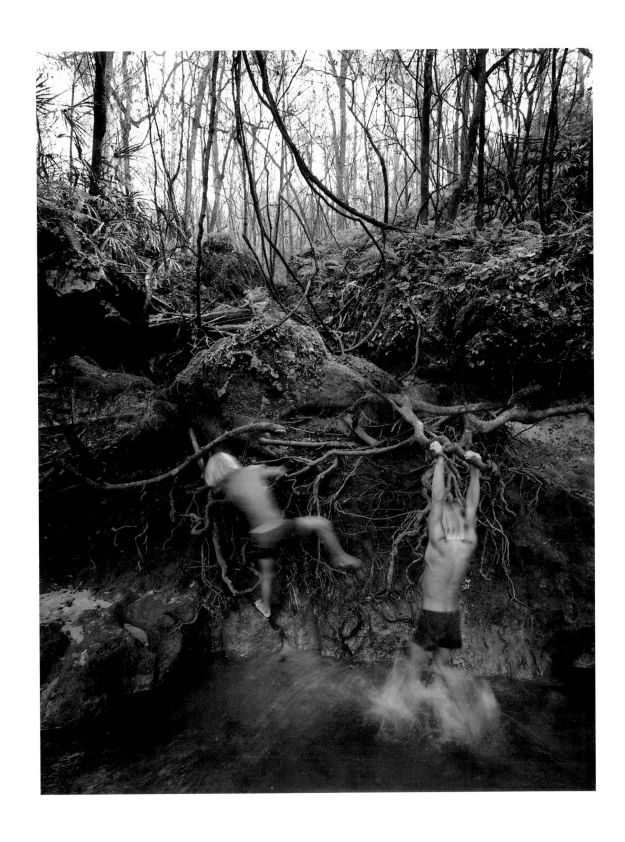

Brice and Brian Under Vines, 1973

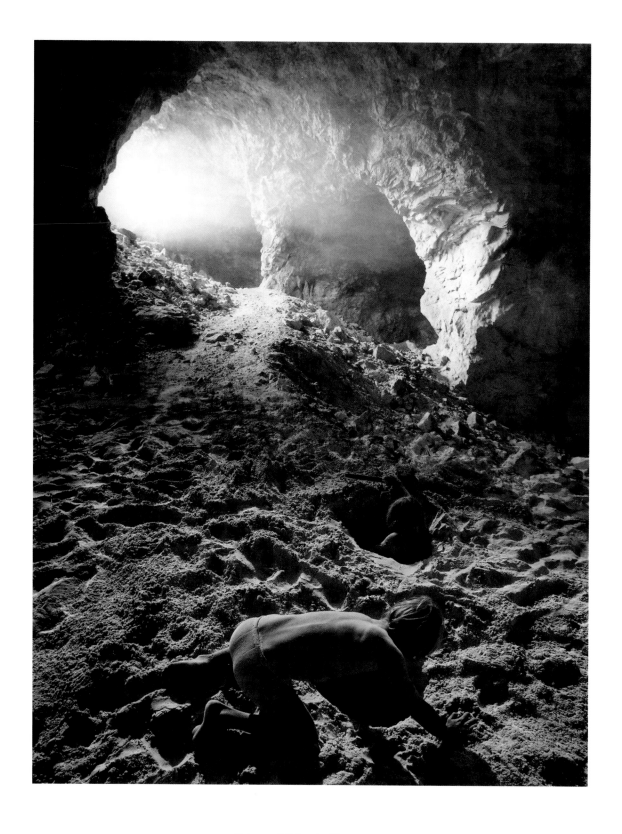

Brice and Brian in Cave, 1992

All Possible Worlds

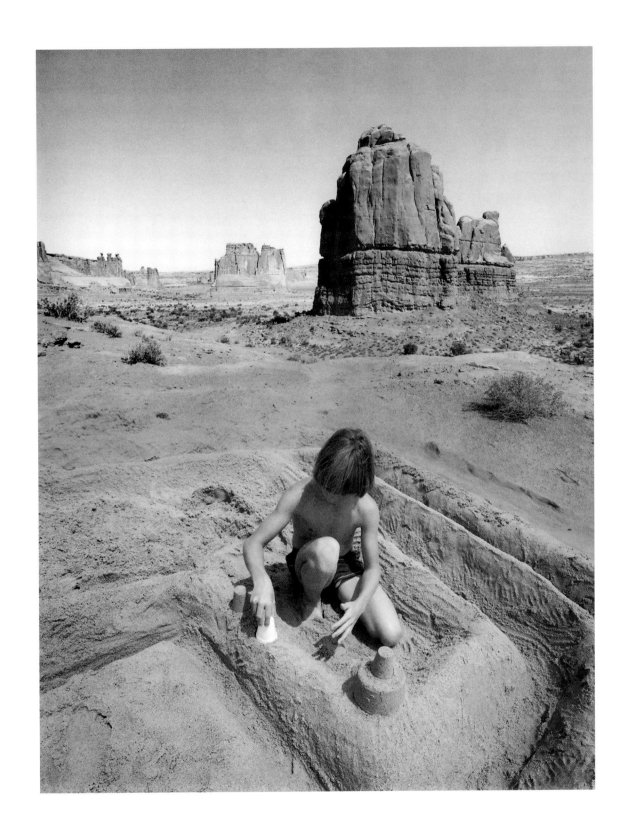

Brian Building Monuments, 1996

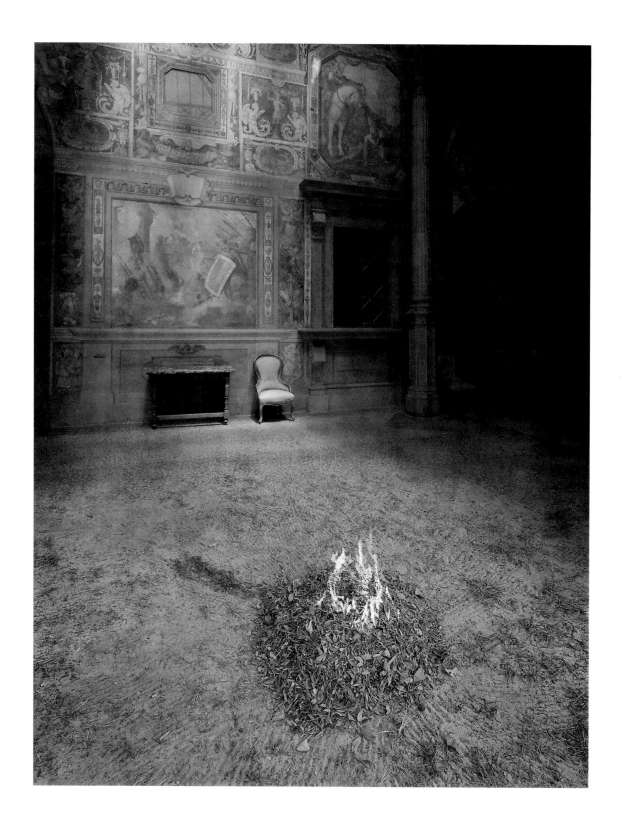

Chair and Burning Leaves, 1990

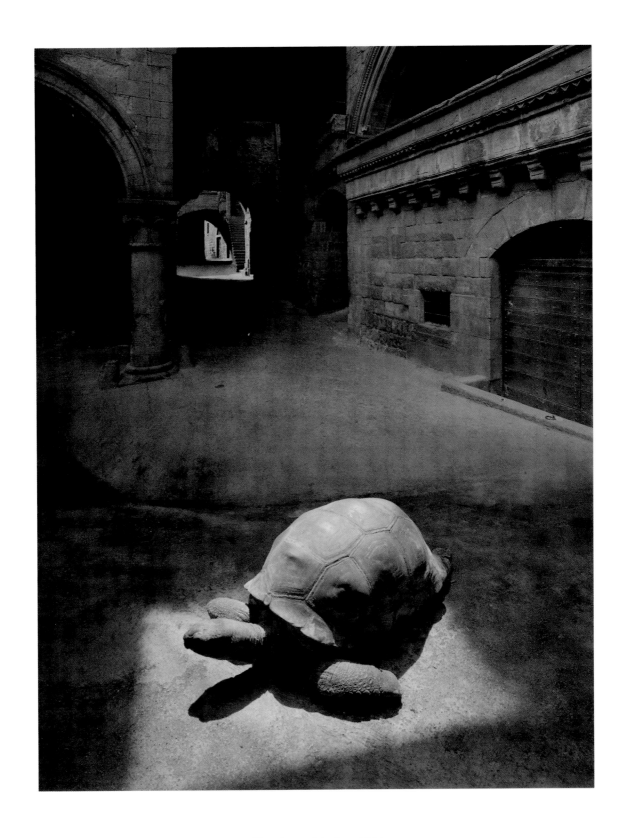

Tortoise and Arches, 1984

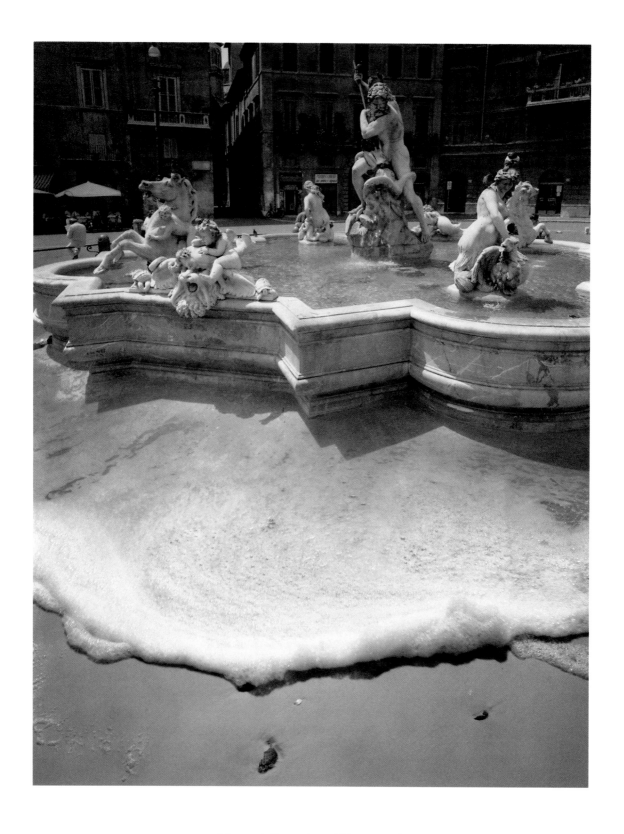

Neptune's Fountain and Wave, 1996

All Possible Worlds

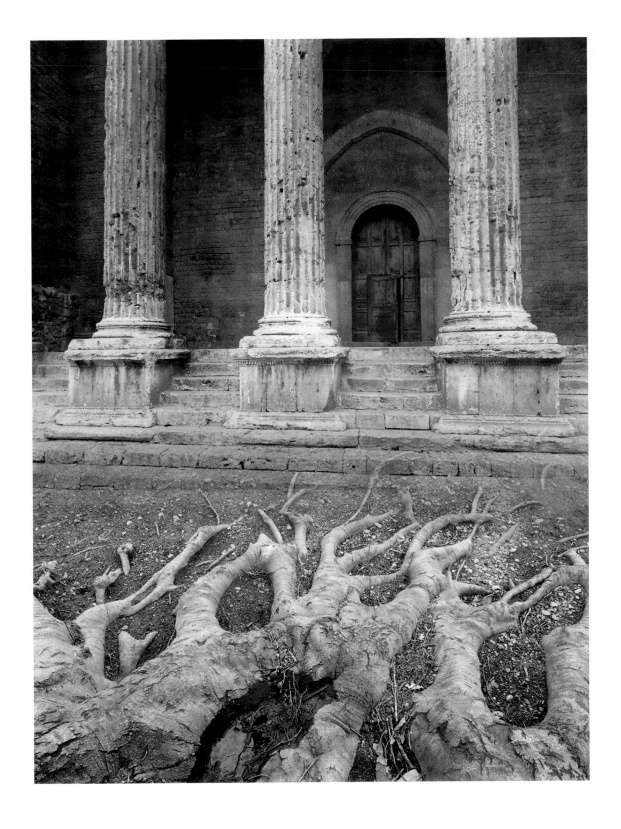

Columns and Roots, 1992

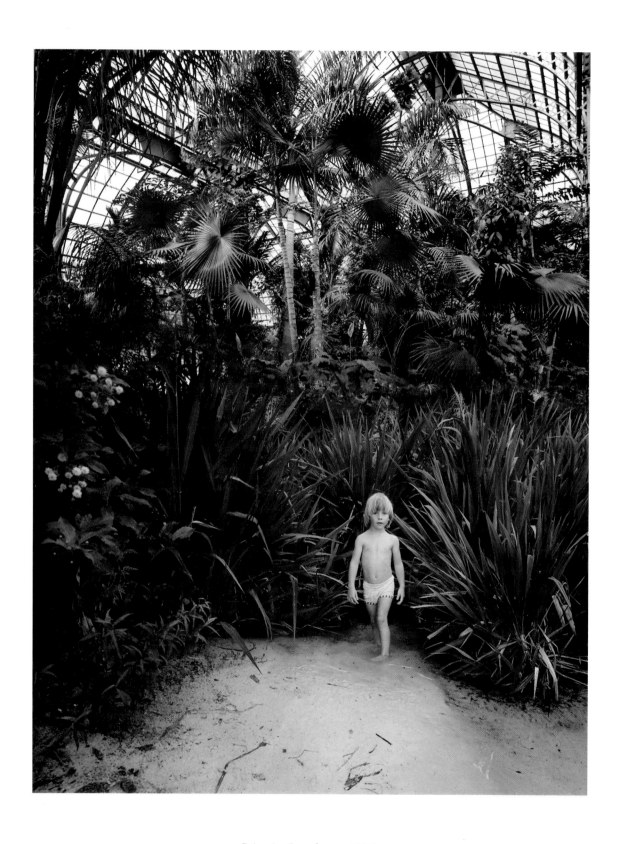

Brian in Greenhouse, 1979

All Possible Worlds

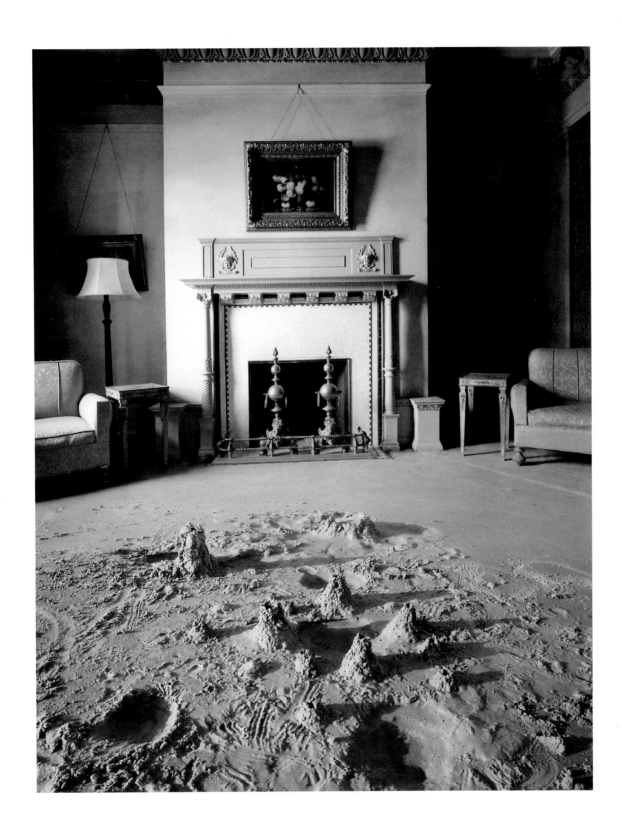

Fireplace and Sand, 1976

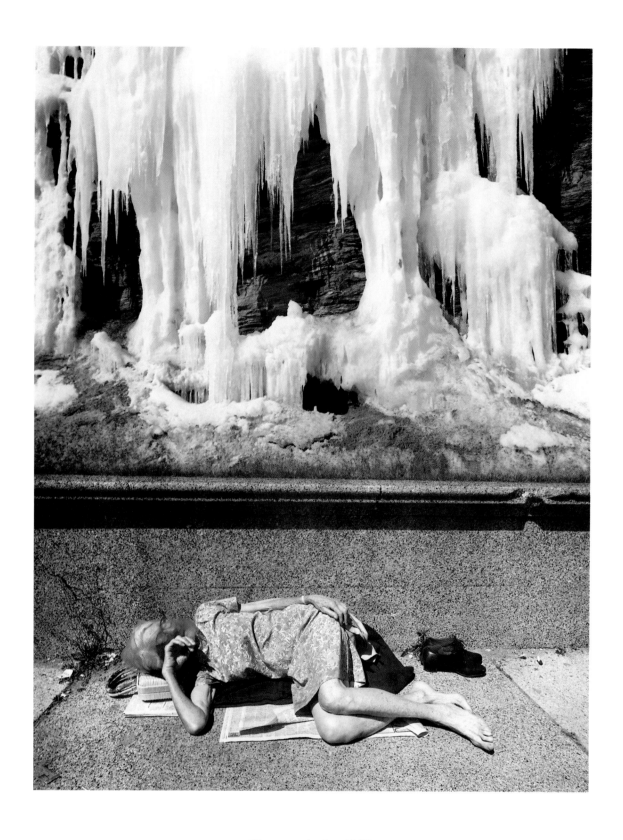

Woman under Ice, 1989

All Possible Worlds

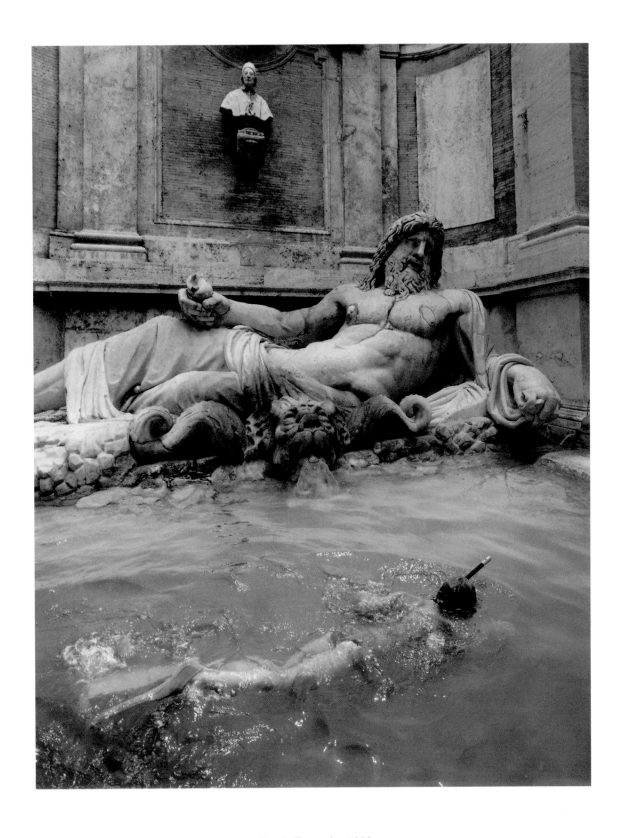

Boy in Fountain, 1992

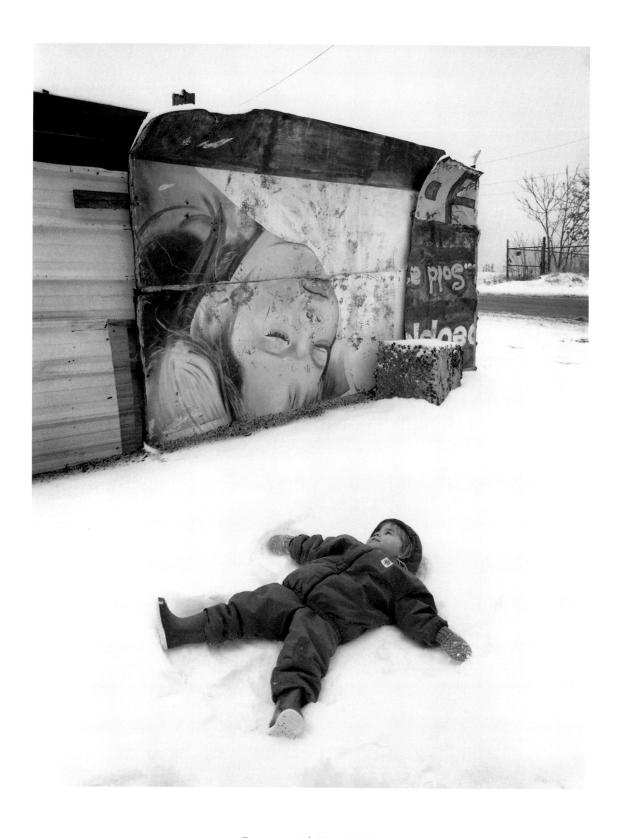

Francesca with Face, 1992

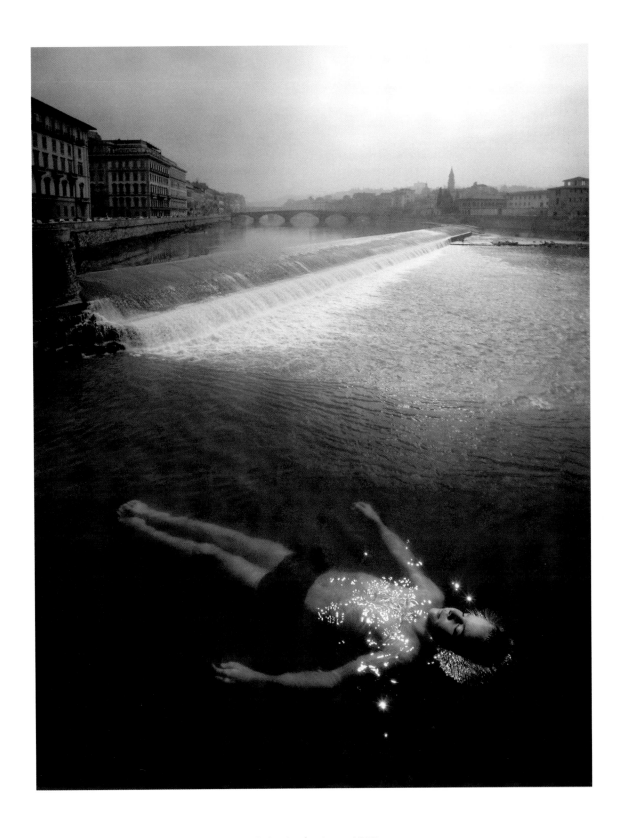

Brian in the Arno, 1997

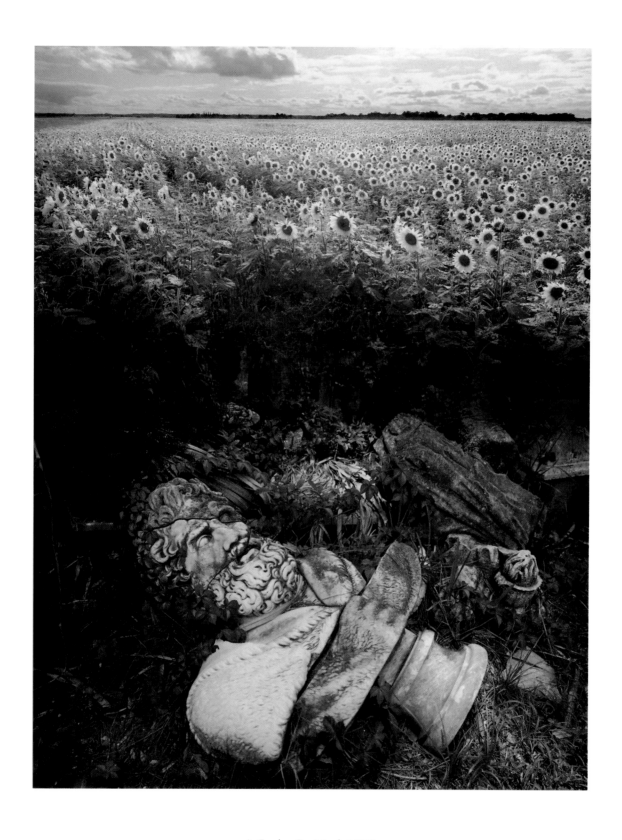

A Garden Revisited, 1996

All Possible Worlds

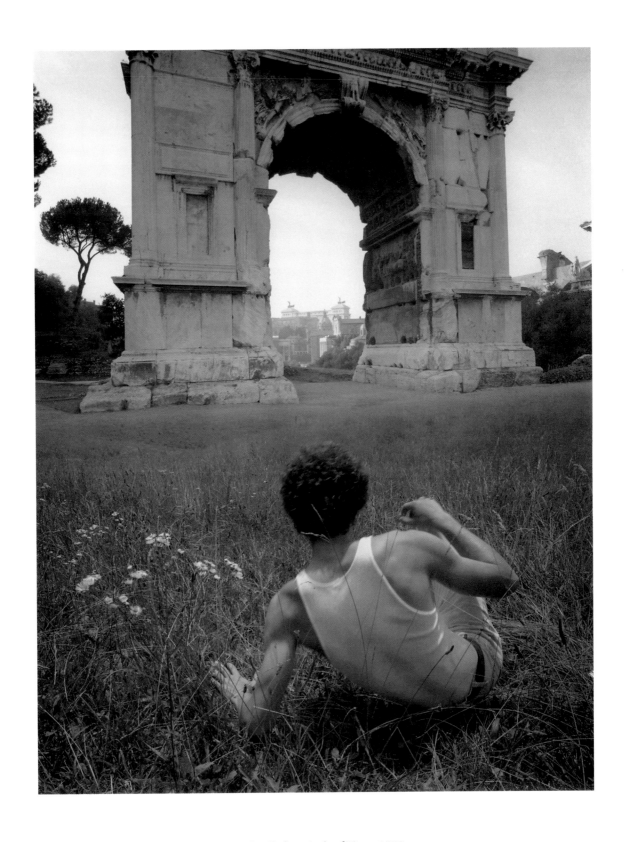

A Man Before Arch of Titus, 1999

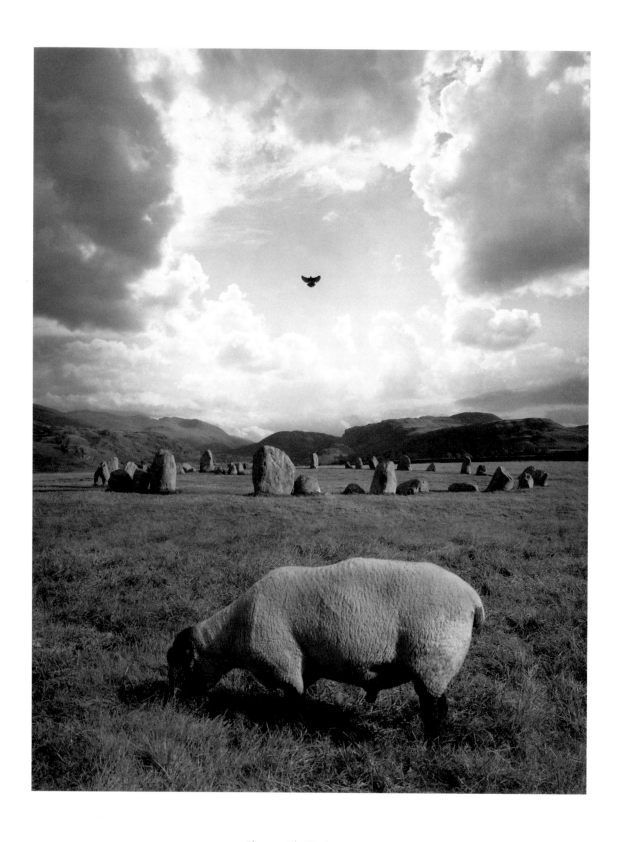

Sheep with Circles, 1997

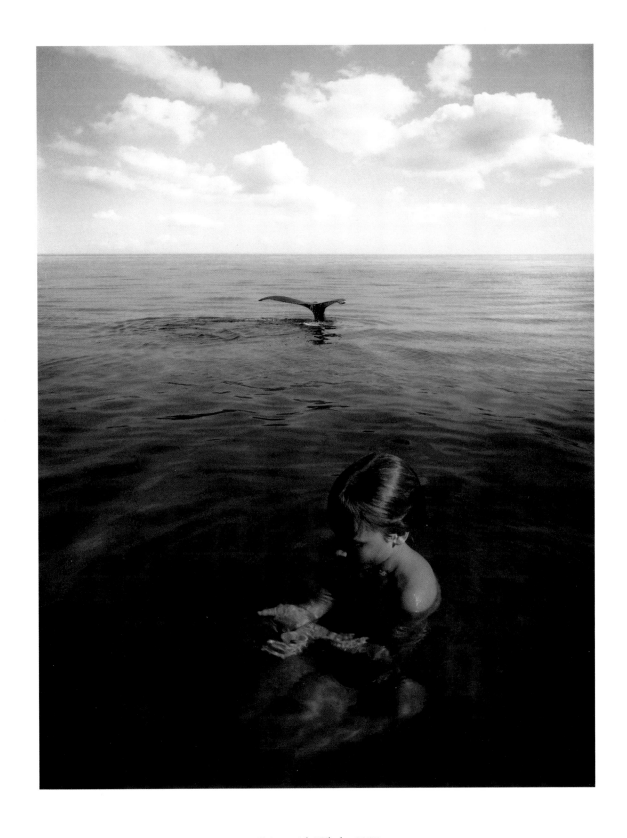

Brian with Whale, 1997

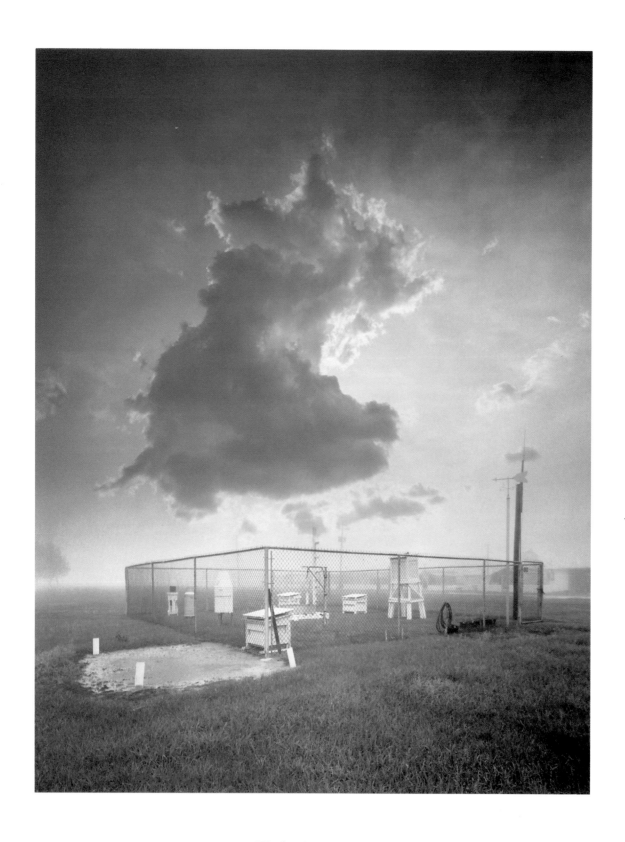

Weather Station, 1997

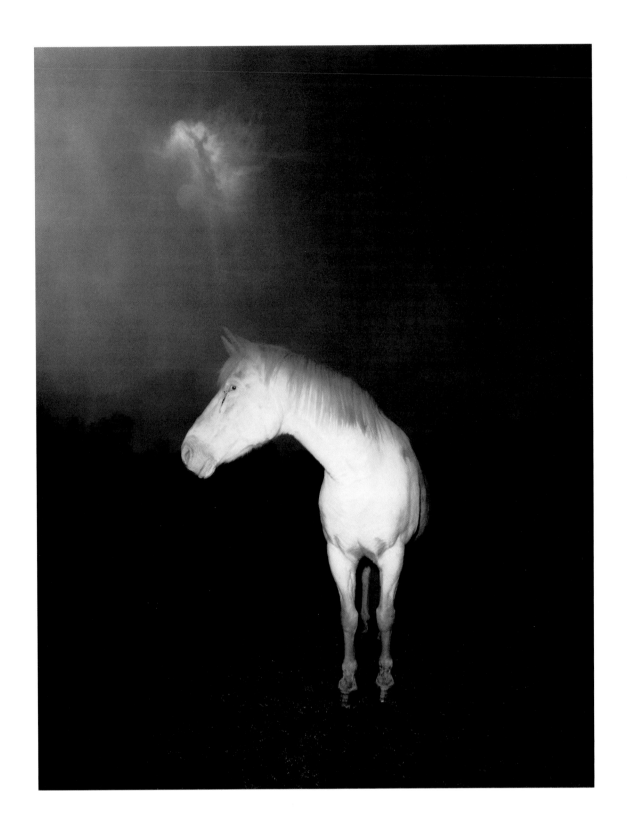

White Horse in Fog, 1979

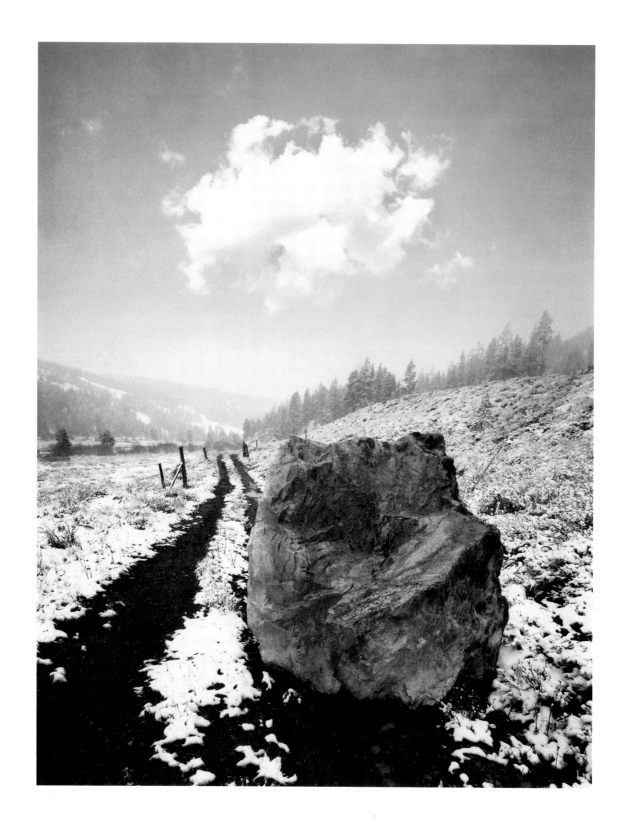

Cloud and Boulder, 1993

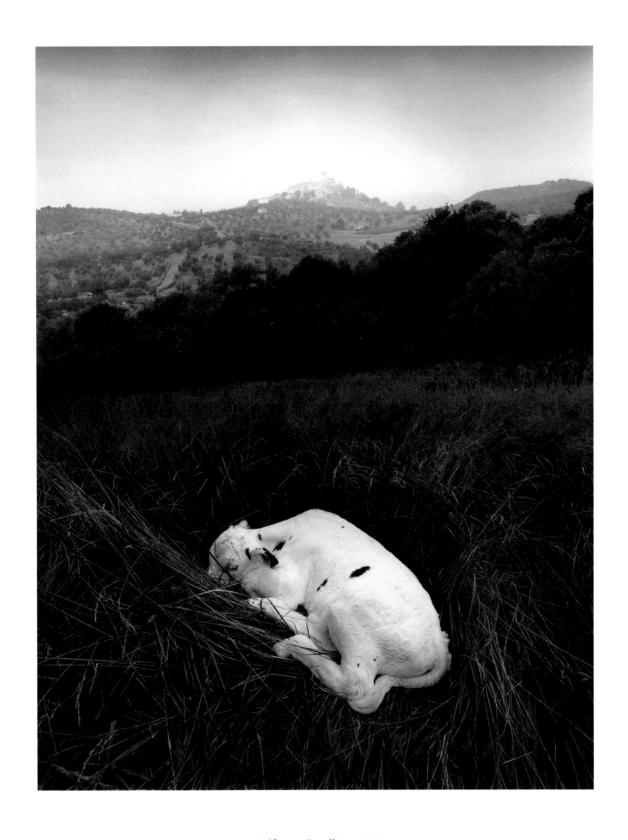

Calf near Capalbio, 1992

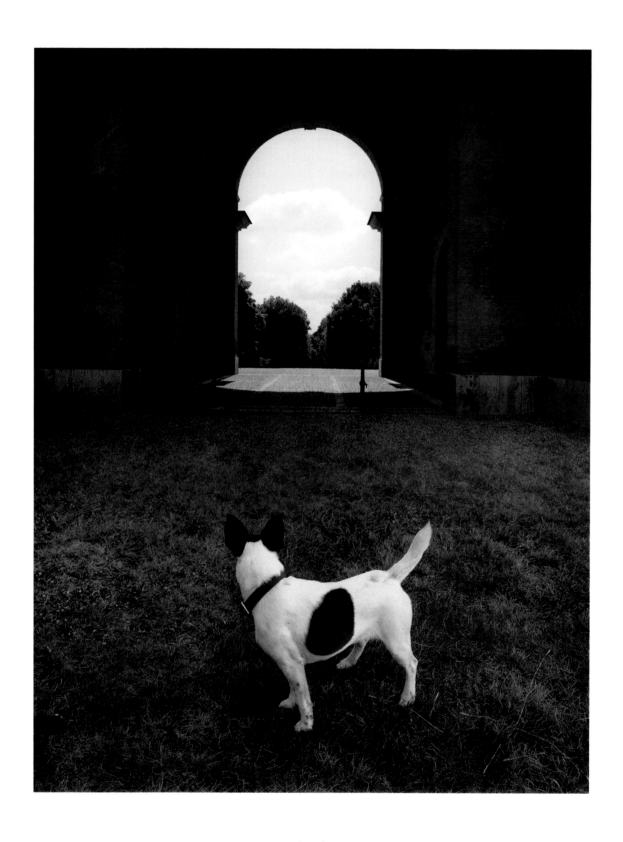

Dog and Arch, 1996

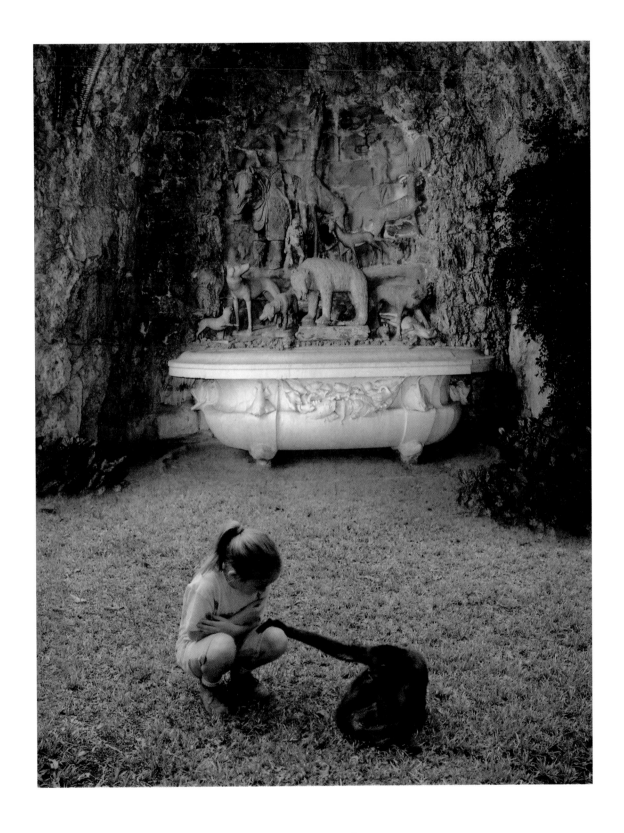

Francesca with Animals, 1997

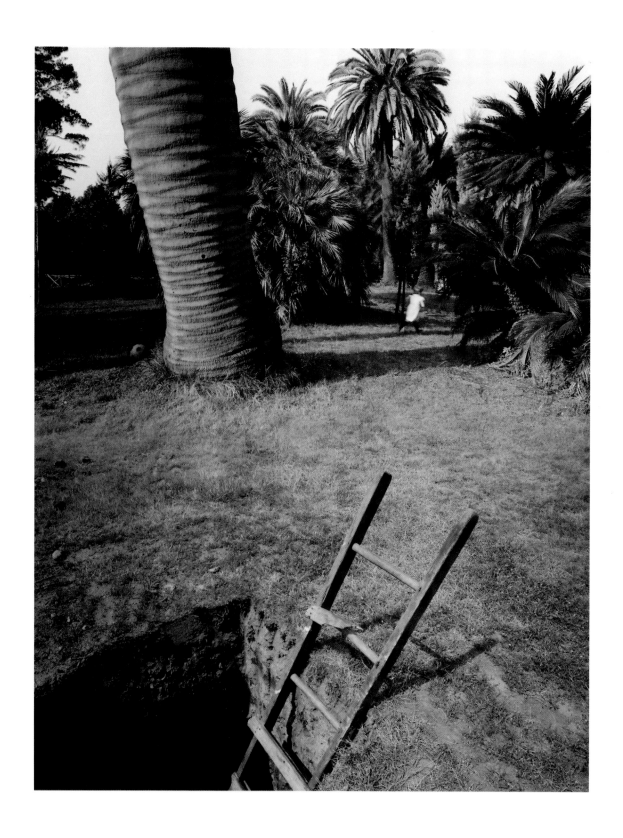

Running Girl with Ladder, 1982

All Possible Worlds

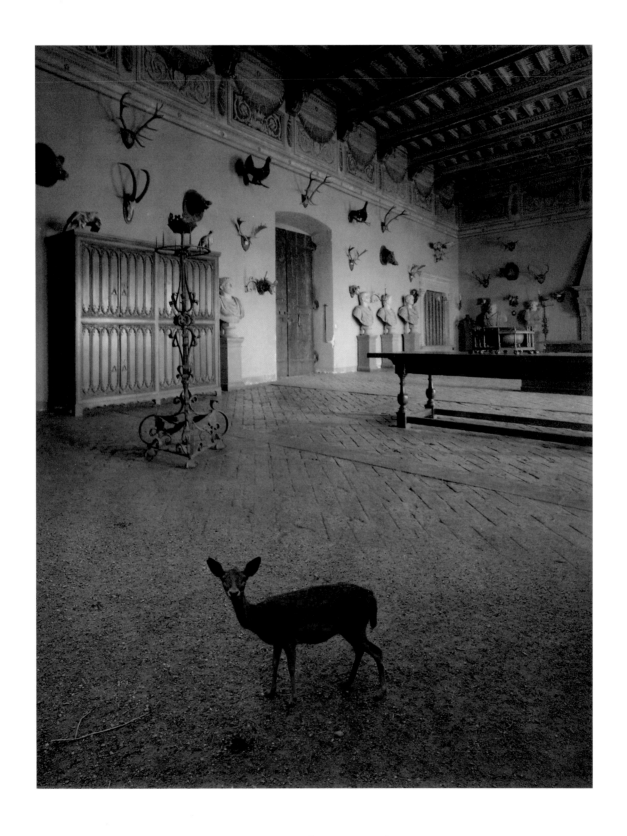

Deer in Trophy Room, 1996

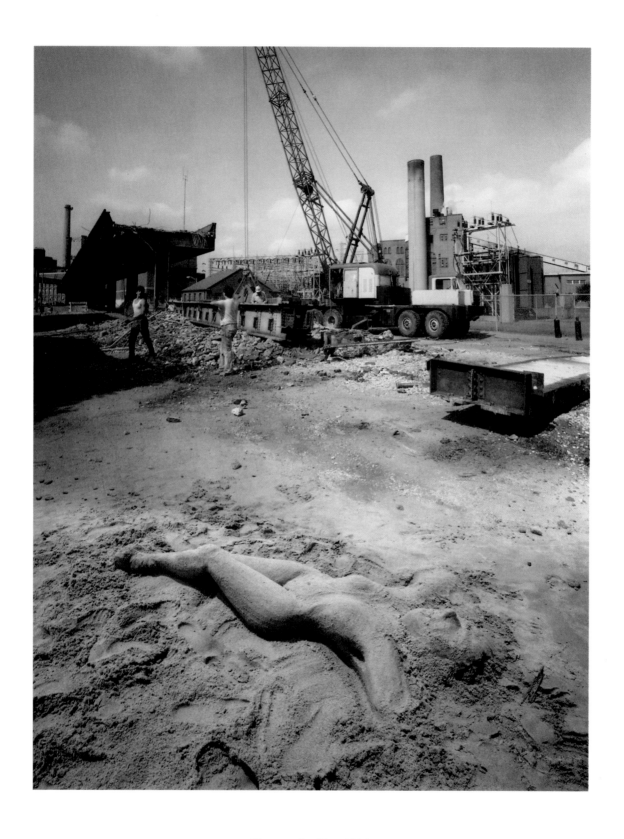

Constructing Eve, 1986

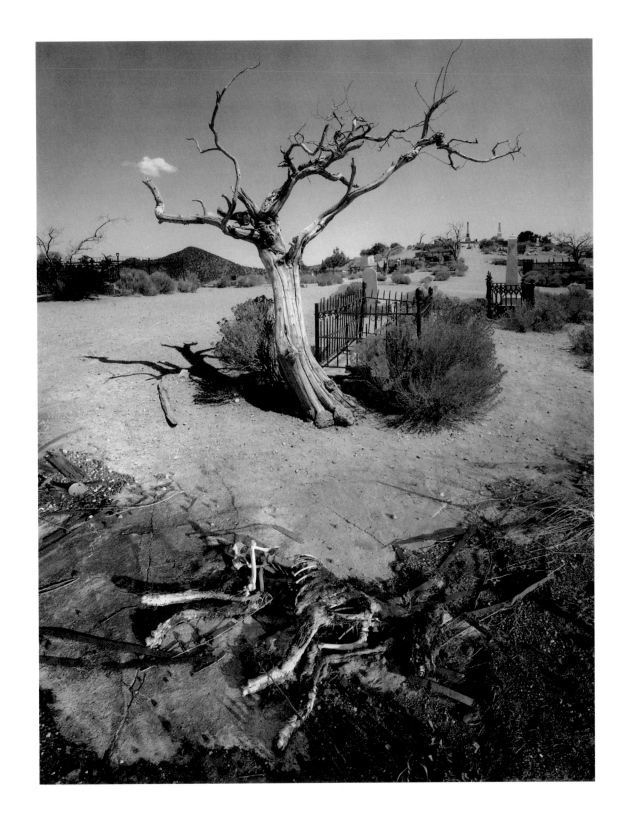

Cloud, Tree and Carcass, 1996

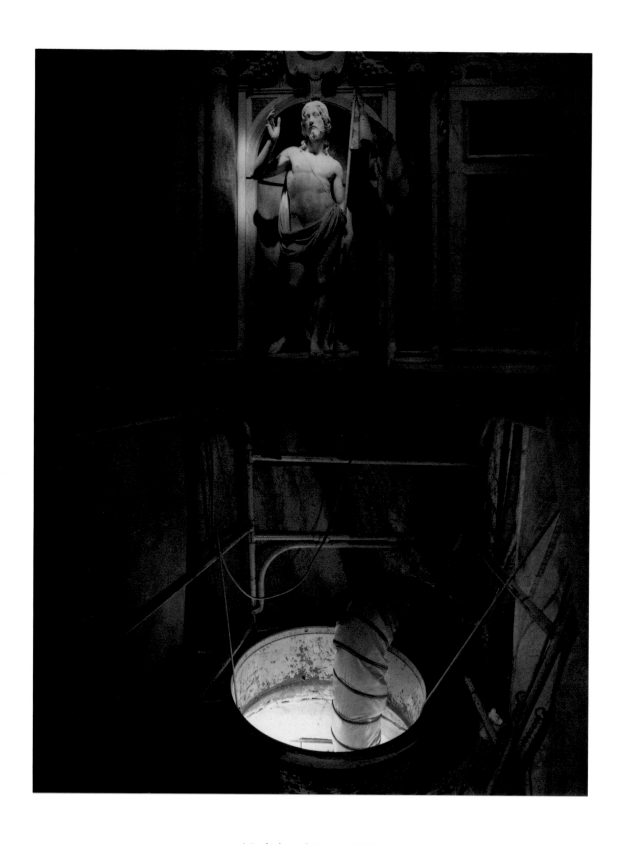

Manhole and Statue, 1997

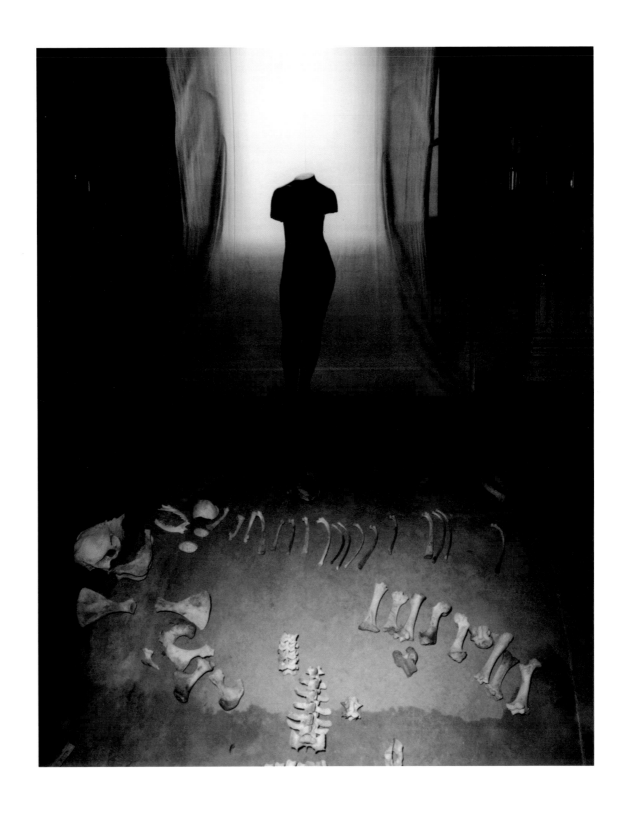

Bones and Body, 1997

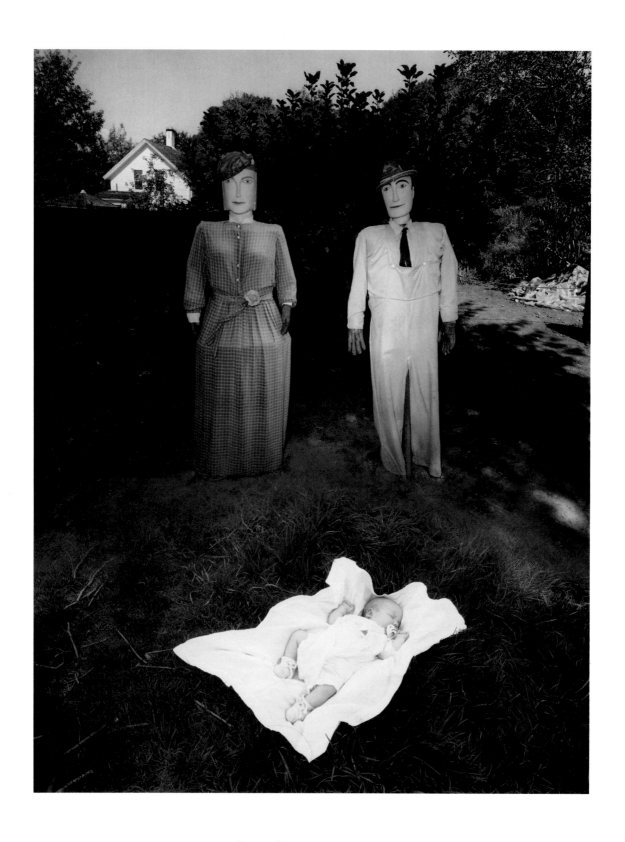

Case and Parent Figures, 1995

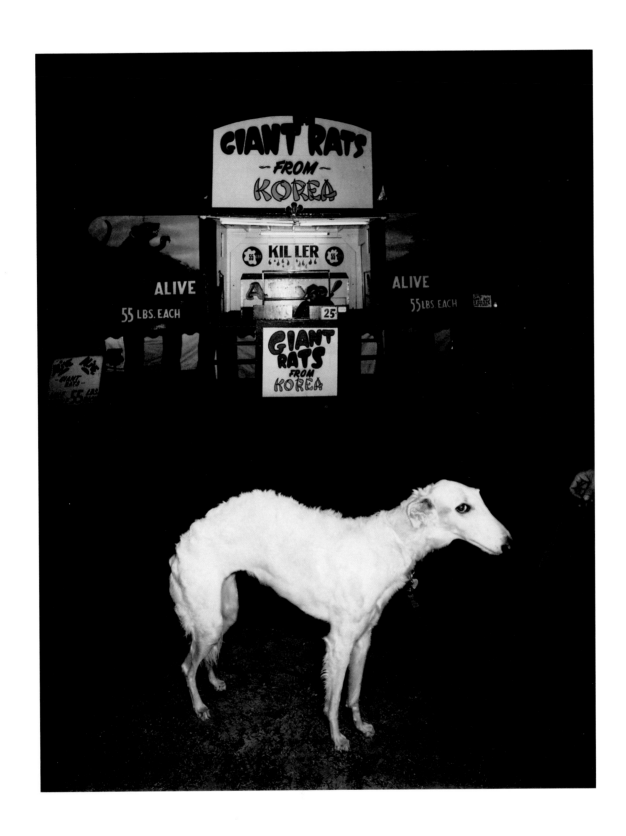

Dog and Giant Rats, 1982

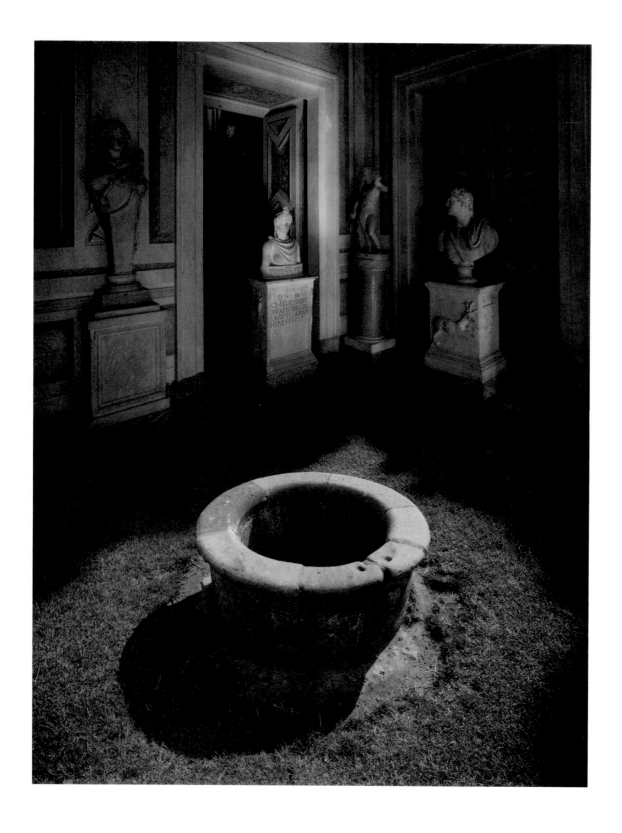

Stone Well and Busts, 1997

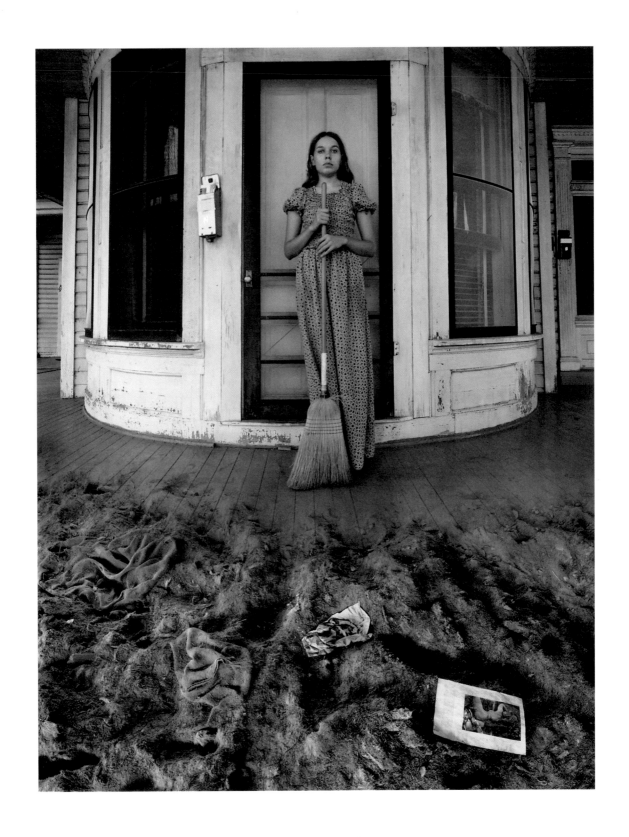

Woman Sweeping Porch, 1978

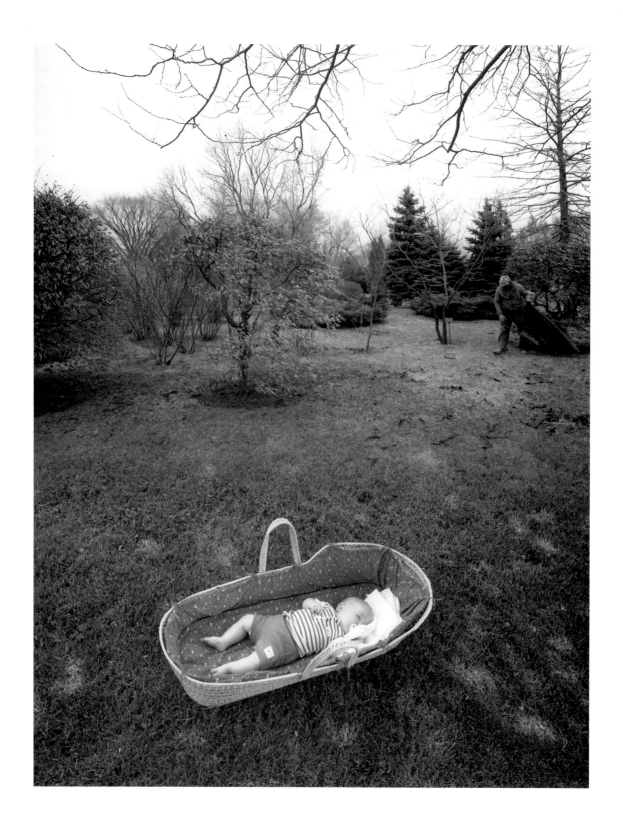

Case in Basket, 1997

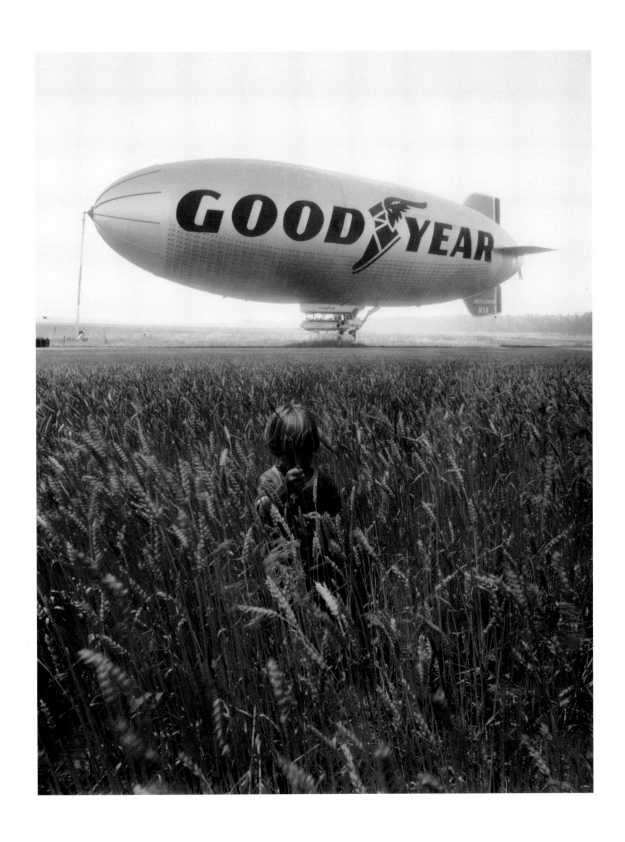

Brian in Field with Blimp, 1993

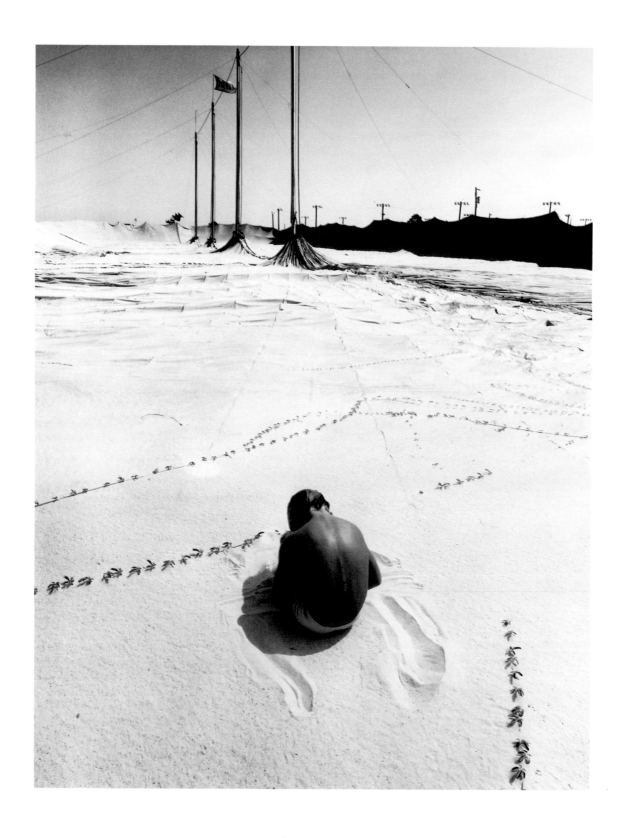

Brian with Circus Tent, 1979

All Possible Worlds

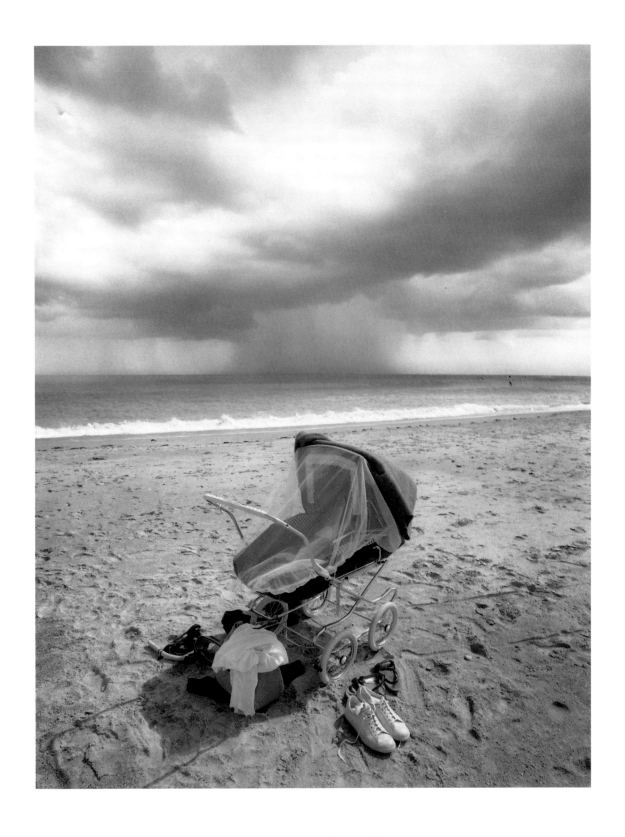

Baby Carriage on Beach, 1996

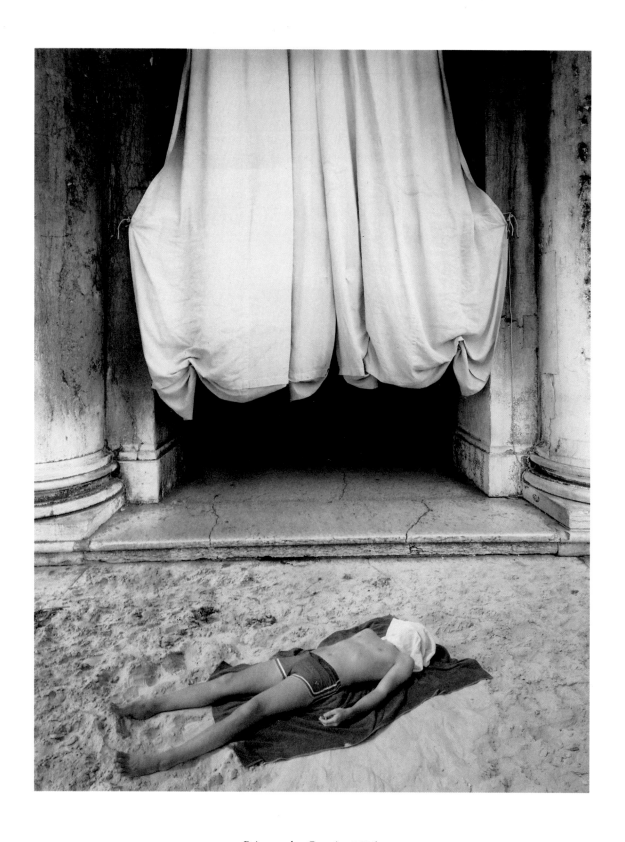

Brian under Curtain, 1996

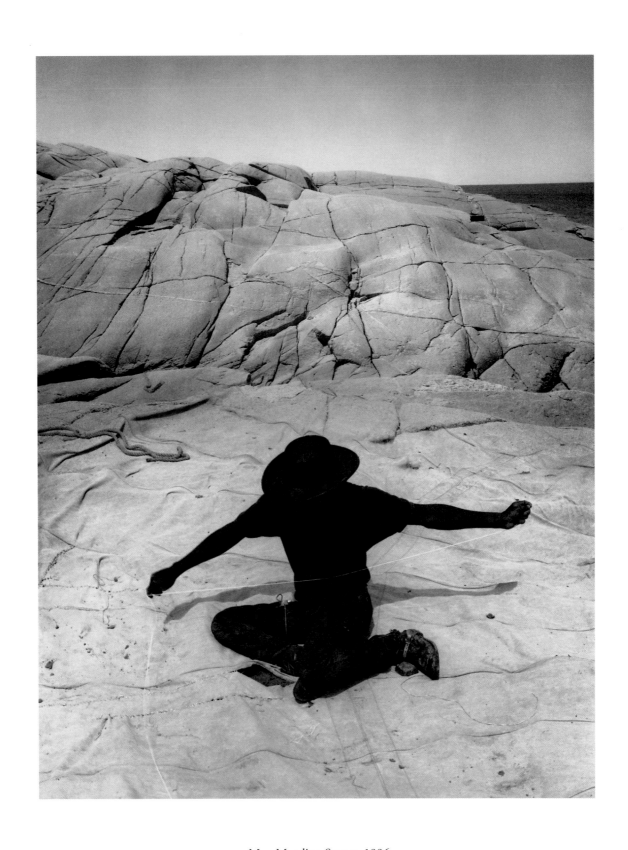

Man Mending Stones, 1996

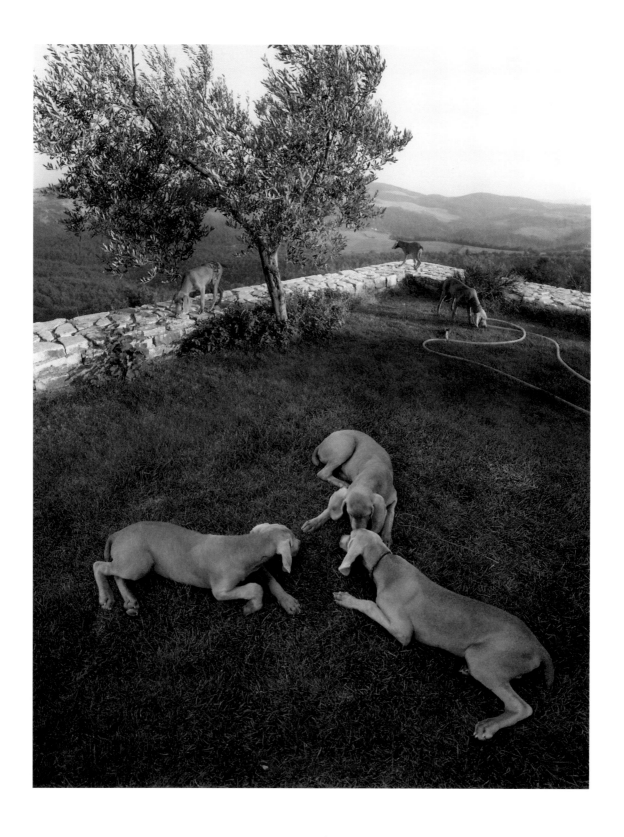

Six Dogs in a Landscape, 1980

All Possible Worlds

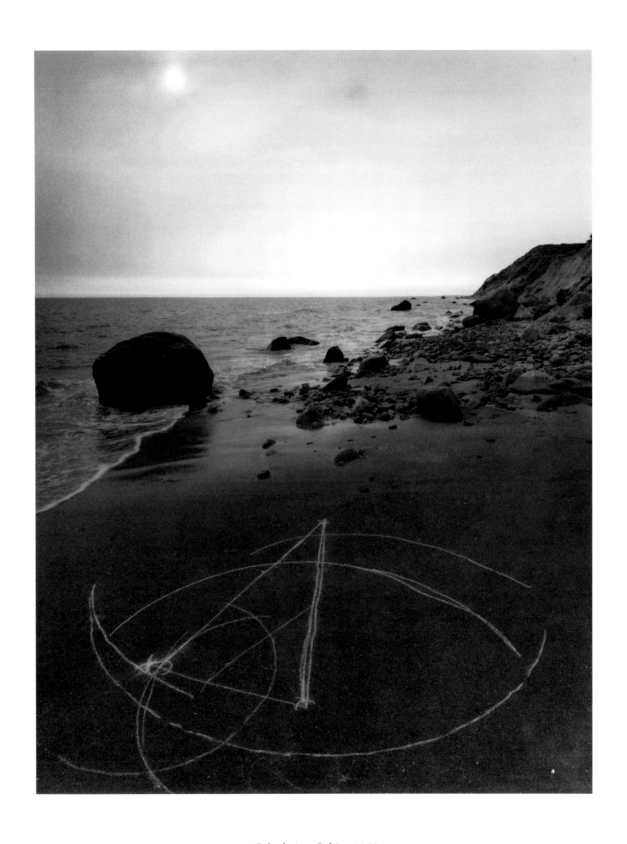

Calculating Orbits, 1998

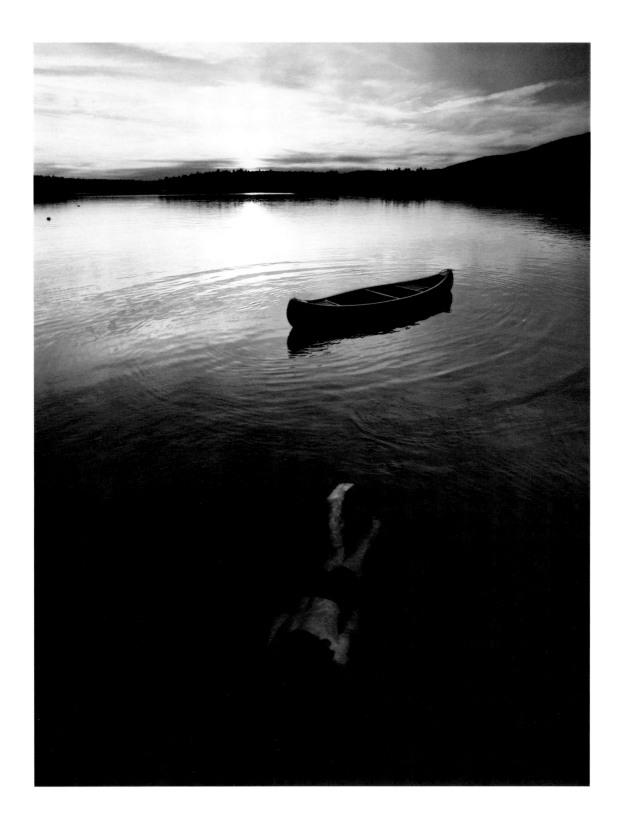

Brian under Canoe, 1980

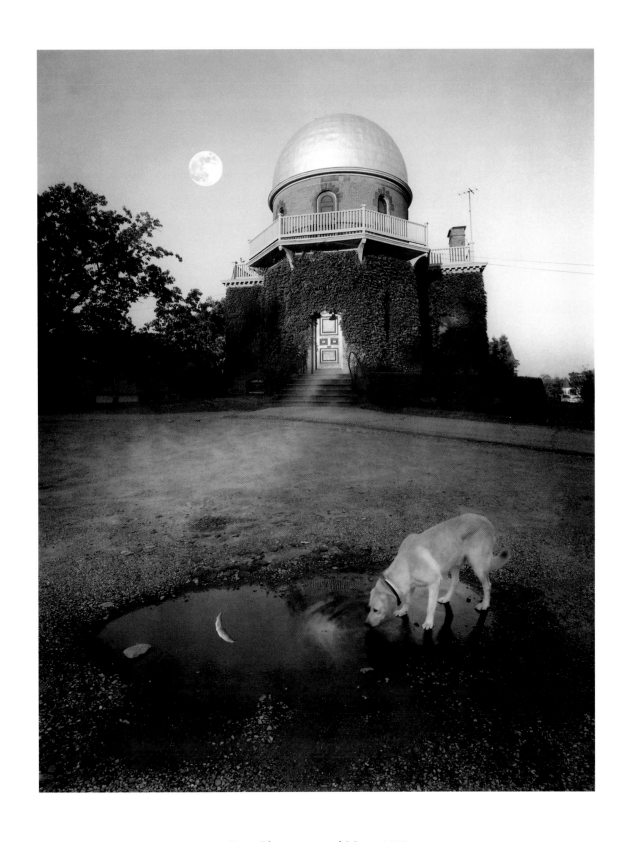

Dog, Observatory and Moon, 1999

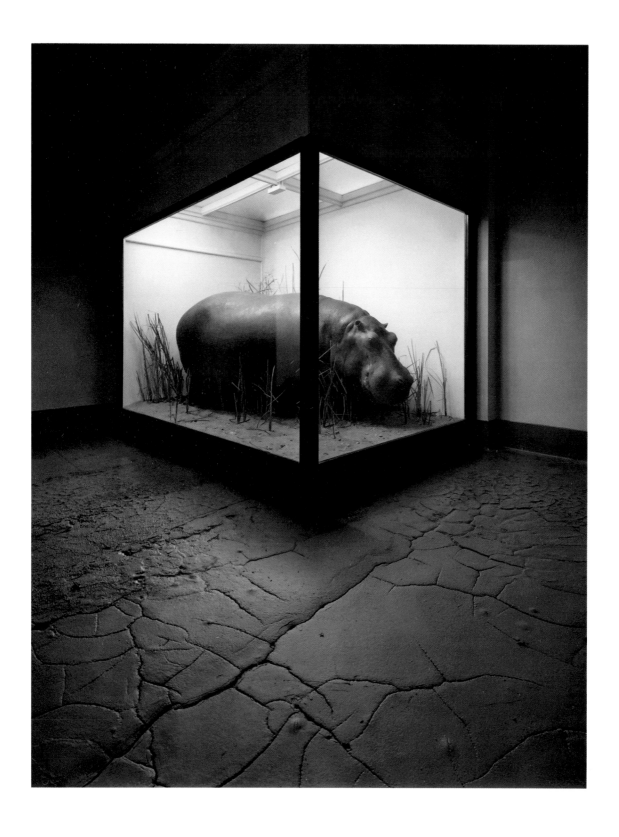

Hippopotamus and Mud, 1983

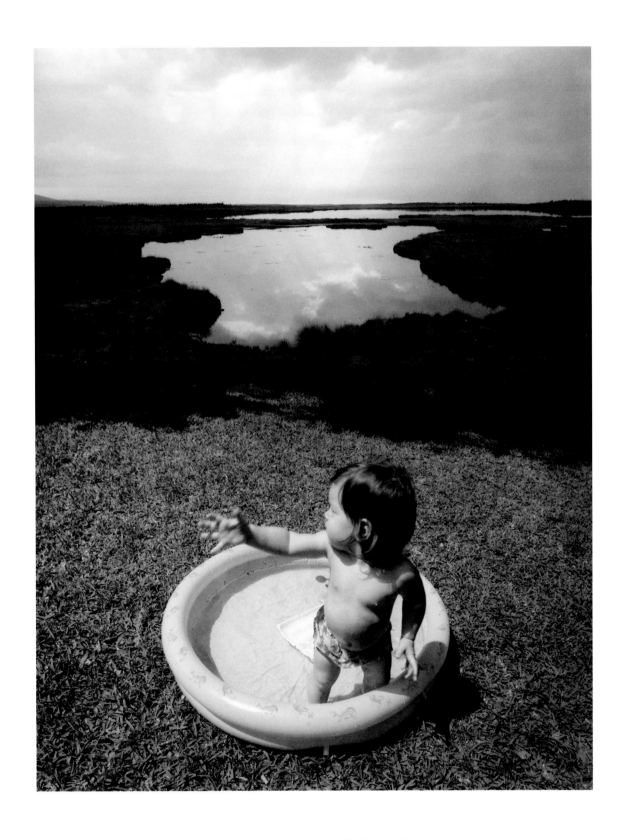

Girl, Wading Pool and Shadow, 1997

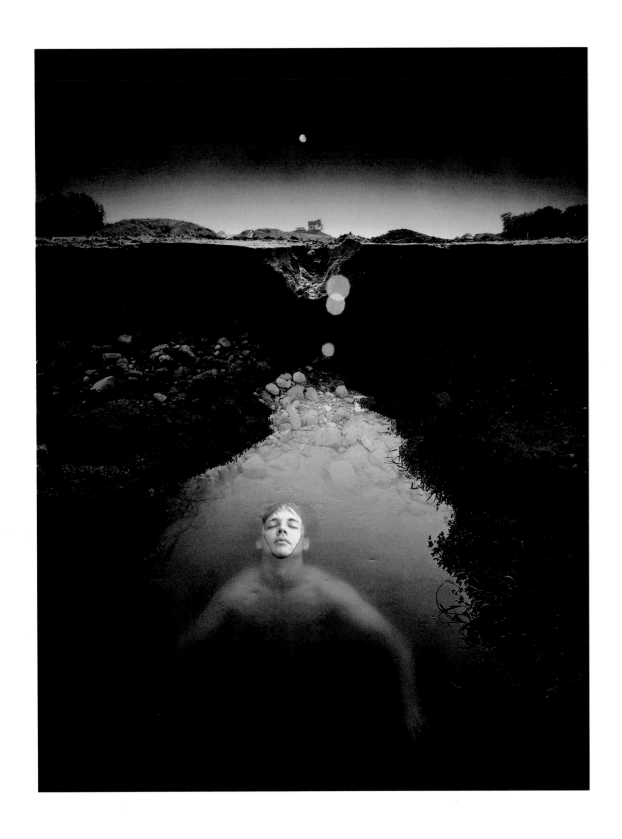

Self–Portrait as a Dreaming Man, 1979

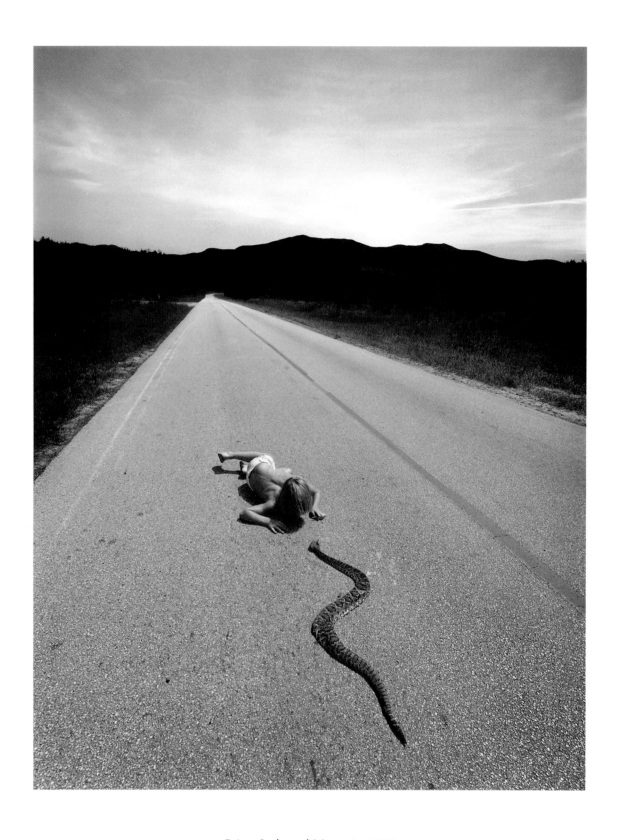

Brian, Snake and Mountain, 1979

All Possible Worlds

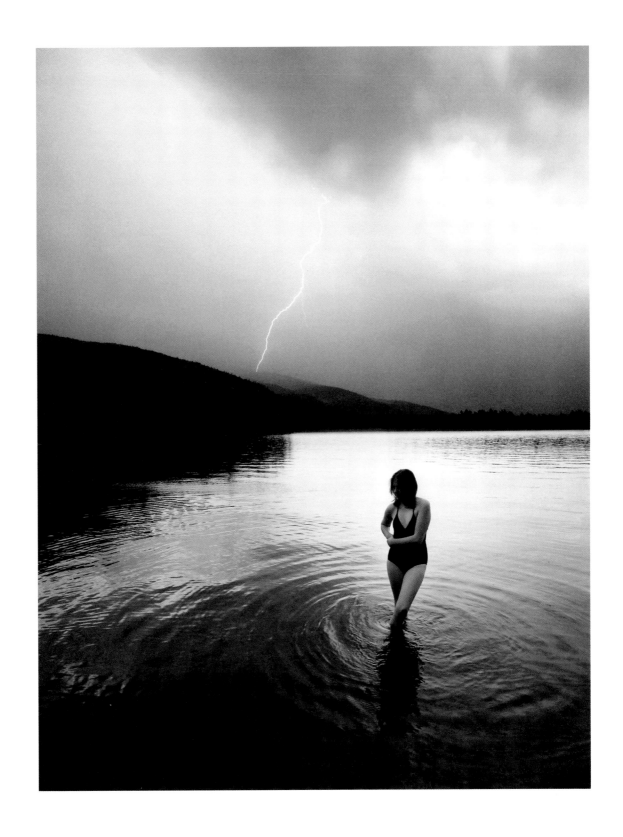

Adel and the Lightning, 1972

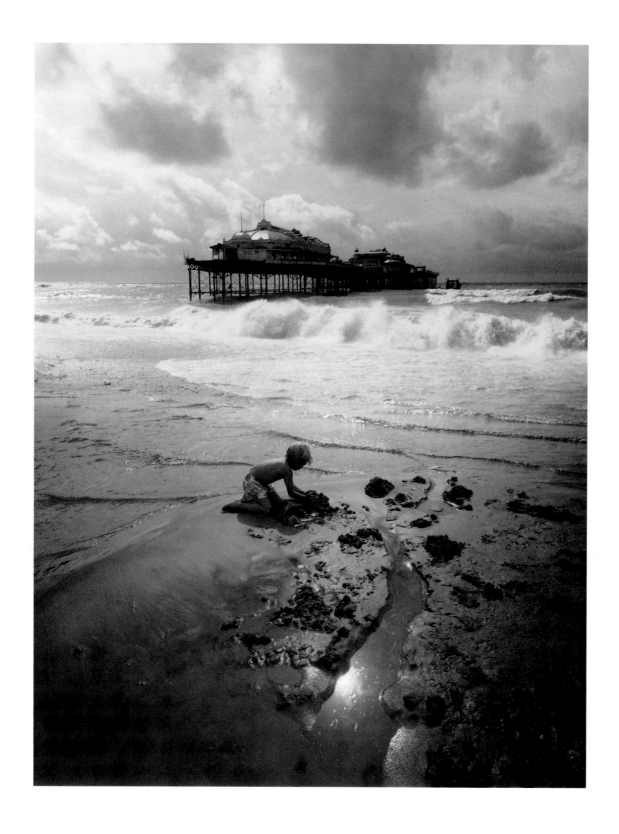

Case and Pavilion, 1995

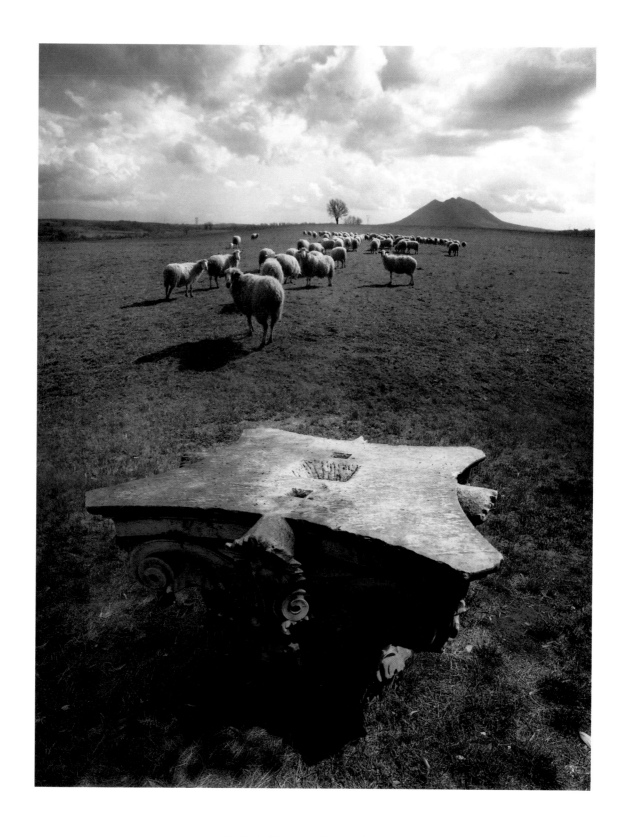

Capitol, Sheep and Mountain, 1993

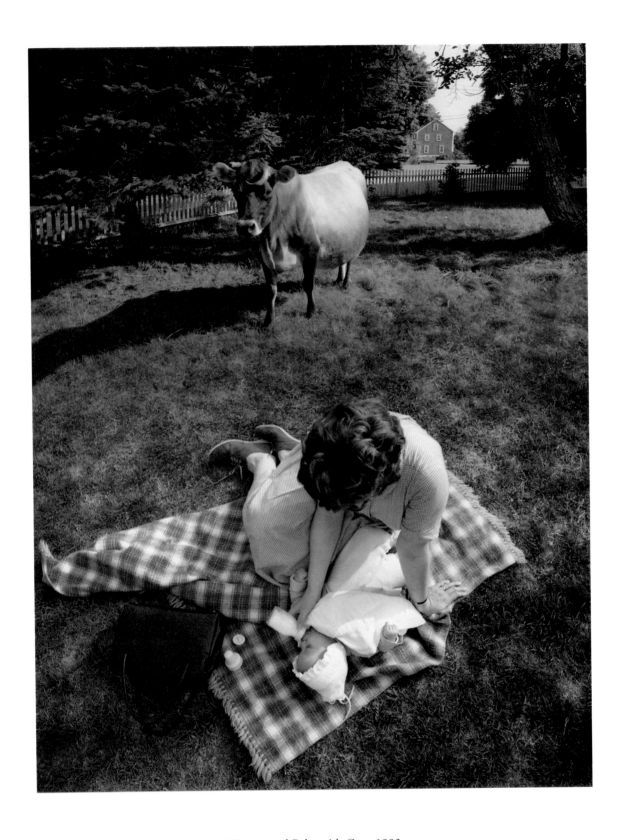

Woman and Baby with Cow, 1993

76

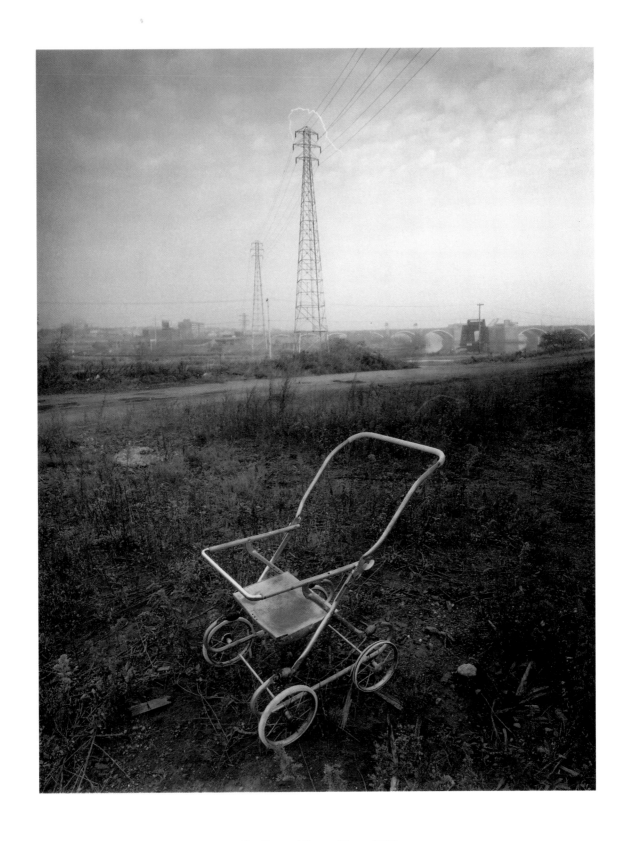

Stroller and Power Lines, 1999

Young Woman with Sarcophagus, 1990

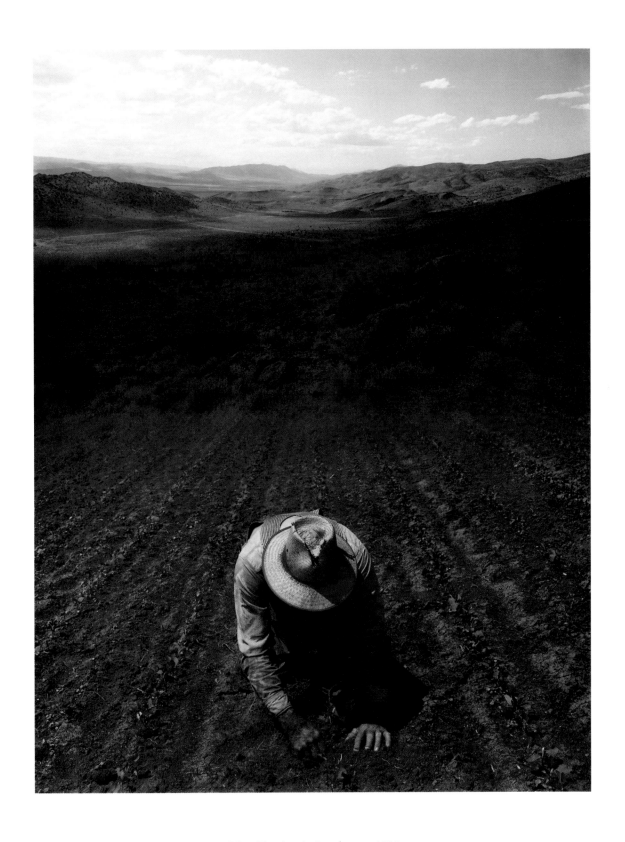

Man Planting in Landscape, 1992

PHOTO-SCULPTURES

The photographs in this section are three-dimensional sculptures, constructed of plastics and film, approximately 5 X 5 X 2.5 inches in dimension. The images are printed on graphic arts film, which is supported between panels of clear plastic at various depths within the box structure. The boxes are to be viewed by transmitted rather than reflected light, available light coming from the rear of the sculpture.

I began working in this direction in the mid-1960's. Already involved in blending foreground and background elements in prints, I wanted to explore the potential of other photographic materials. After much experimentation, I found that the transparent photographic image, layered in a real three-dimensional space, had the potential to create the hyper-real spaces of the photo-sculptures. This process lent itself to the subject matter of my photographs and allowed me to combine picture elements that could not be resolved in the paper print, creating miniature realities.

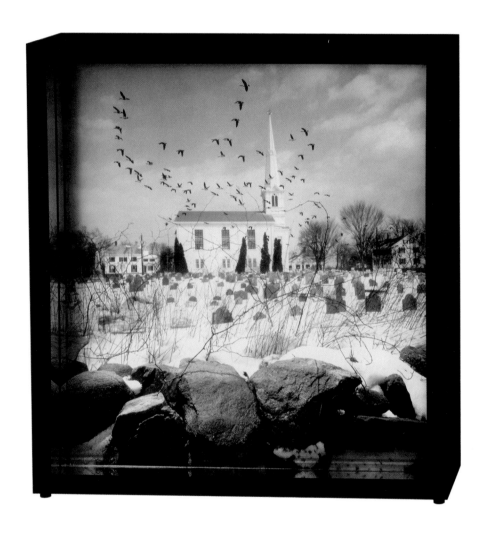

Return of the Flock, 1996

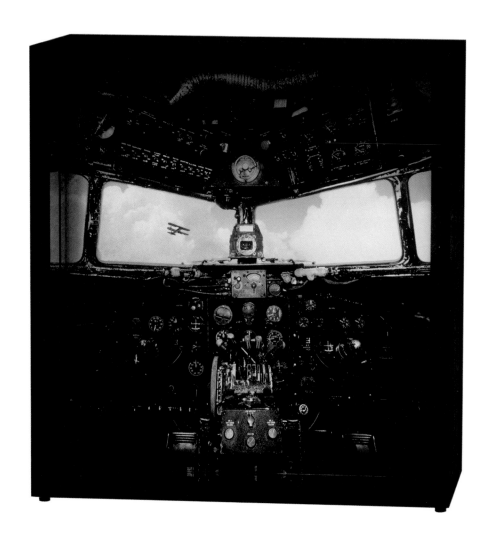

Cockpit II, 1996

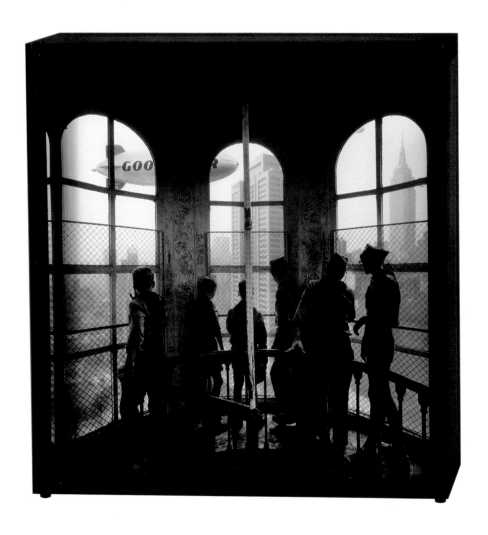

Observation Room, 1983

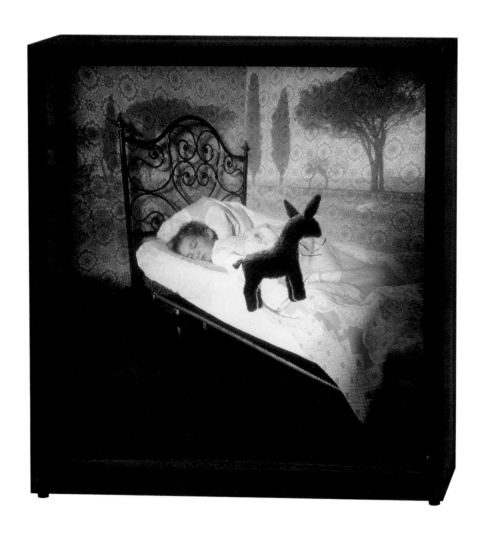

Case and Lambs 11, 1994

All Possible Worlds

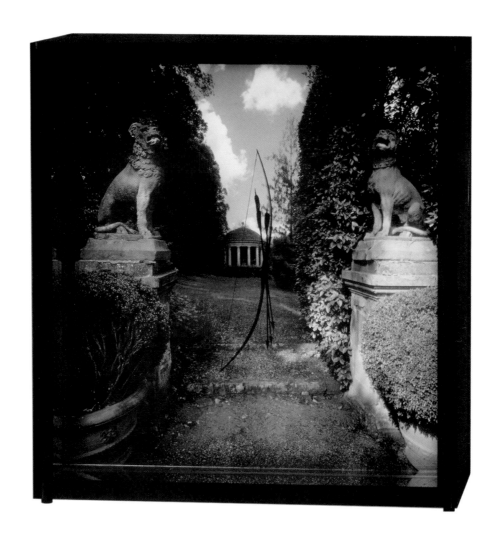

Diana's Garden, 1996

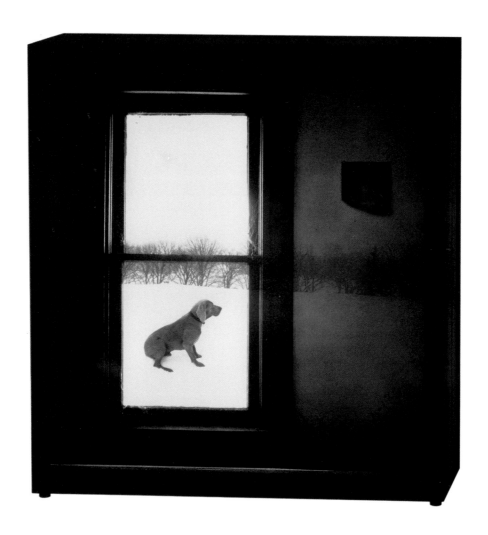

Dog and JFK, 1996

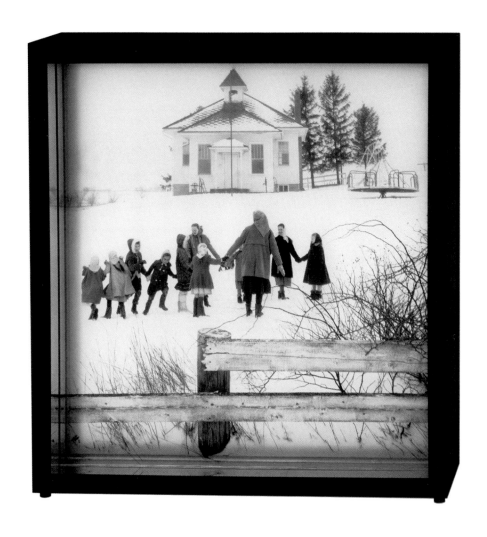

Iowa School House, 1984

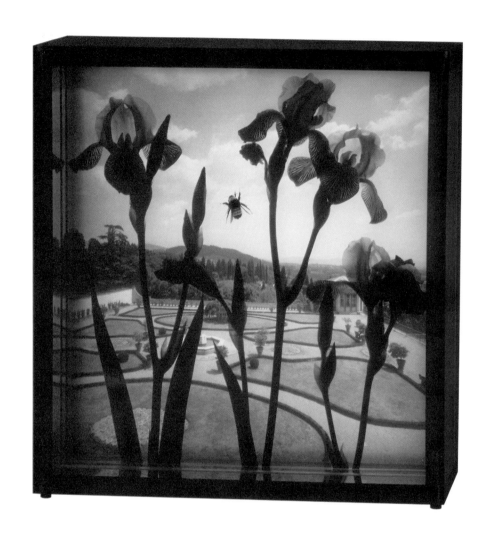

Italian Garden and Bee, 1996

All Possible Worlds

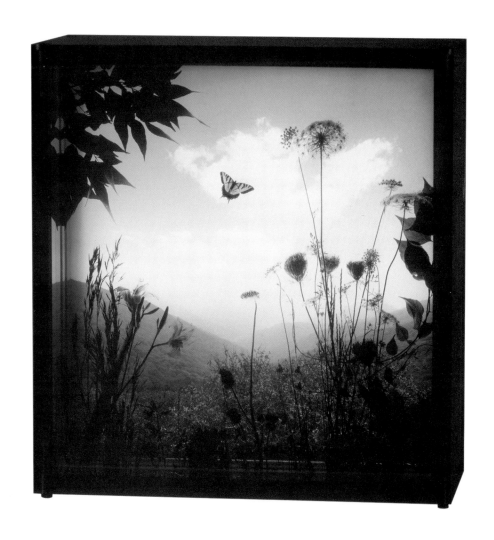

Summer Landscape, 1993

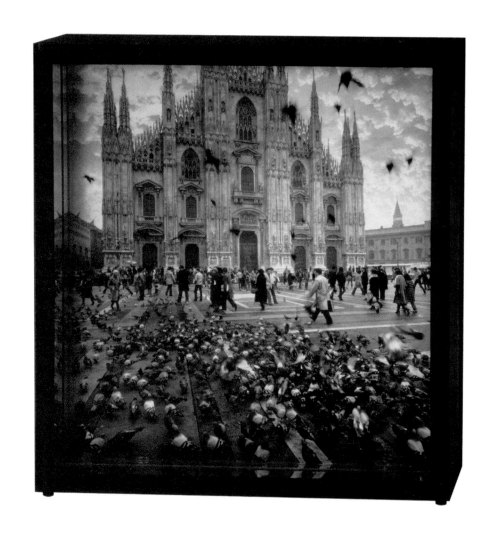

Morning in Milan, 1994

All Possible Worlds

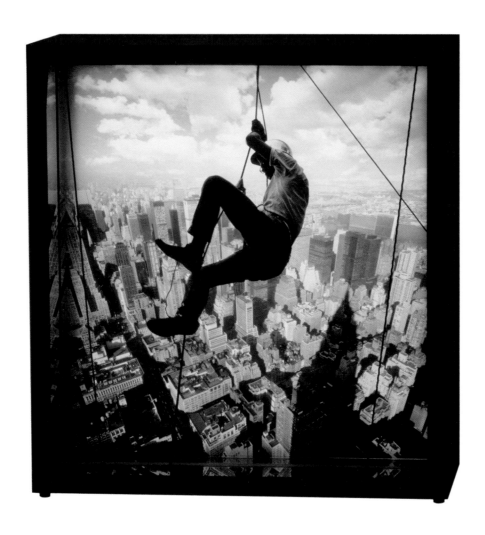

Man over Manhattan, 1996

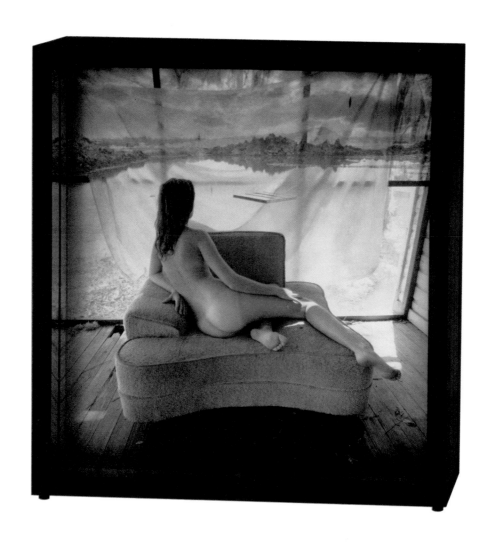

Odalisque (after L.B.), 1979

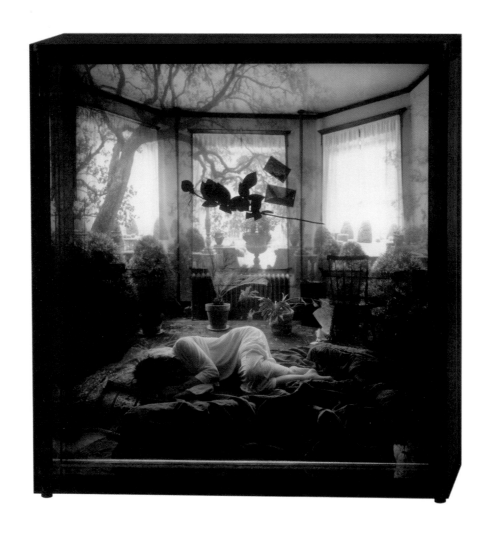

Floating Rose, 1978

IMAGE NOTATIONS

As Robert R. Craven so aptly described in his
essay, *Treading the Brink*, the photographs in this
book are made by combining two or more sepa-
rate images to construct an illusion of a
possible new reality, one that maintains a
continuity of time and space. Once the images
have been combined, it's difficult to visualize
them in their original contexts. As you can see
in the notations, the original images may have
been taken thousands of miles and decades
apart. Discovering which foregrounds and
backgrounds will fuse together to produce a
new, and for me, signifying event is an
important part of my creative experience.

Lake Tahoe, California, 1987

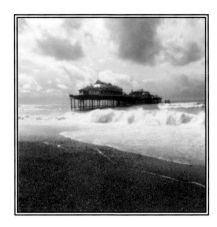

Brighton Beach, England, 1994

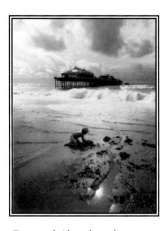

Case and Abandoned
Pavilion, 1995

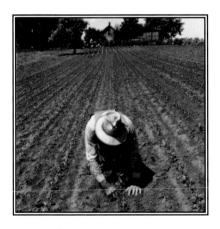

Iowa, 1962

Nevada, 1986

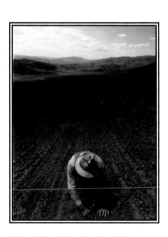

Man Planting in Landscape,
1992

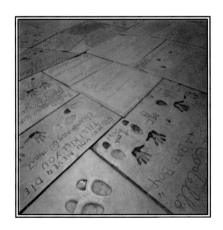

Los Angeles, California, 1987

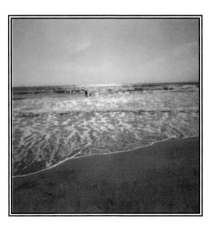

Pacific Ocean, 1987

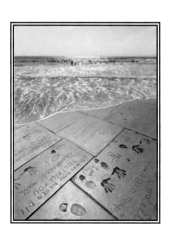

Star Imprints and Pacific
Ocean, 1992

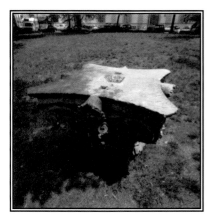

Florence, Italy, 1987

Monte Sorati, Italy, 1981

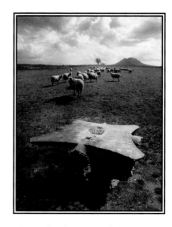

Capital, Sheep, and
Mountains, 1993

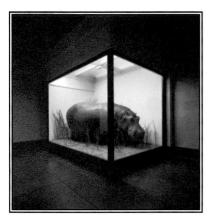

Chicago, 1971

Kentucky, 1983

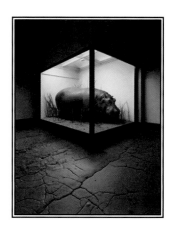

Hippopotamus with Mud,
1983

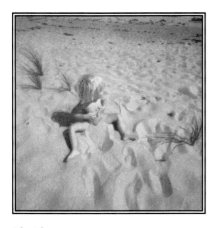

Florida, 1983

New Hampshire, 1990

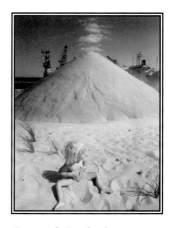

Case with Sand Pile, 1994

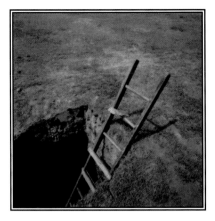

Providence, Rhode Island, 1978

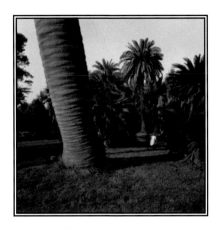

Rome, Italy, 1981

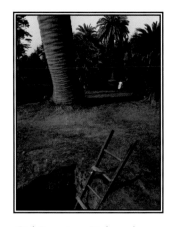

Girl Running, Hole and Tree, 1983

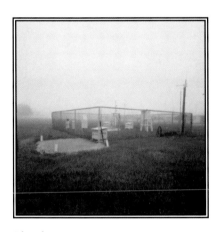

Florida, 1972

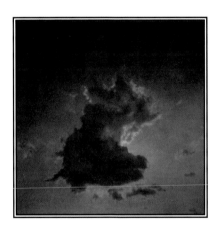

Italy, 1981

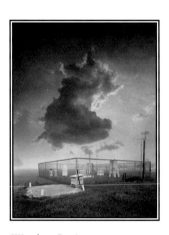

Weather Station, 1997

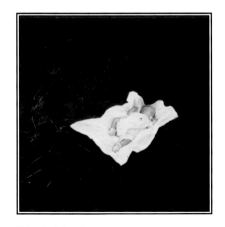

Rhode Island, 1980

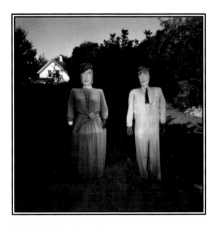

Rhode Island, 1980

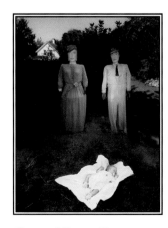

Case and Parent Figures, 1995

DOUGLAS D. PRINCE

Born: 1943 in Des Moines, Iowa
Currently resides in Portsmouth, New Hampshire

❧

EDUCATION

1968 M.A. University of Iowa
(Photography major)
1965 B.A. University of Iowa
(Fine Arts major)

❧

SELECTED SOLO EXHIBITIONS

1995 "Doug Prince: Photographs,"
Saint Anselm College, Manchester, NH.
1994 "Douglas Prince: 20 Years,"
1973–1993, Witkin Gallery,
New York, NY.
"Perceptions and Reflections,"
The Print Club, Philadelphia, PA.
1990 "Douglas Prince: Italian Observations,"
PRC, Boston, MA.
1987 "Doug Prince, Italian Observations,"
Witkin Gallery, New York, NY.
"Doug Prince, Italian Observations,"
Kathleen Ewing Gallery, Washington, DC.
1981 "Two Person Show," with Mimmo
Jodice, Rondanini Galleria d'Art
Rome, Italy.
1980 "Selected Work," Witkin Gallery,
New York, NY.
Addison Gallery of American Art,
Phillips Academy, Andover, MA
1975 Light Gallery, New York, NY.
Deja Vue Gallery, Toronto, Canada.
1973 Light Gallery, New York, NY.
1967 Des Moines Art Center,
Des Moines, IA.

❧

SELECTED GROUP EXHIBITIONS

1998 "Photography's Multiple Roles,"
The Museum of Contemporary
Photography, Chicago, IL.
"Moments in Time: Master Photographs
from the Currier,"
The Currier Gallery of Art,
Manchester, NH.
"Portraits: New Hampshire Society of
Fine Arts Photographers,"
Holderness School, Holderness, NH.
1997 "The Constructed Photograph:
Jo Babcock, Gillian Brown, Maria
Magdalena Campos-Pons, and Douglas
Prince," The Addison Gallery of
American Art, Andover, MA.
"Celebrating 10 Years: A Chronological
History of Exhibitions,"
Catherine Edelman Gallery,
Chicago, IL.
"Animal Instincts," Catherine Edelman
Gallery, Chicago, IL.
"Jaeger's Projection, New Landscape
Photography,"
Art Space, New Haven, CT.
"Body in the Lens," The Montreal
Museum of Fine Arts,
Montreal, Canada.
1996 "Reframing Tradition," Creative Arts
Workshop, New Haven, CT.
"Two," Witkin Gallery, New York, NY.
"Florida National X," Museum of
Fine Arts, Florida State University,
Tallahassee, FL.
1995 "Under 8 x 10 Inches," Witkin Gallery,
New York, NY.
1994 "Photos: Flora and Fauna,"
The Point Gallery, York Harbor, ME.

1993 "The 68th Annual Competition,"
 The Print Club, Philadelphia, PA.
 Juror: Charles Hagen, awarded
 solo exhibition.
 "Photo Synthesis," two–person
 exhibition with Jerry Uelsmann,
 Robert Klein Gallery, Boston, MA.

1992 "Flora Photographica," Montreal
 Museum of Fine Arts, Montreal, CD.
 "New England Photographers '92,"
 Danforth Museum, Framington, MA.

1990 "Ciao Italia!," Catherine Edelman
 Gallery, Chicago, IL.
 "Photography: From Fact to Symbol,"
 UNF, Jacksonville, FL.

1989 "Behold," Museum of Contemporary
 Photography, Columbia College,
 Chicago. IL.
 "Photomontage/Photocollage: The
 Changing Picture," Jan Turner Gallery,
 Los Angeles, CA.
 "The Second Ten Years," Witkin Gallery,
 New York, NY.

1988 "The Altering Eye: Layered
 Photographic Images,"
 Arts Club of Chicago.

1987 "Light Work 1986–1987 Grants"
 "Photography and Art, Interactions
 Since 1946," Los Angeles County
 Museum of Art, Los Angeles, CA.

1986 "City Light," ICP/Midtown,
 New York, NY.
 "Photography in Chicago Collections,"
 The Art Institute of Chicago.

1985 "Work Based on Boxes," Museo Tamayo,
 Arte Contemporaneo International
 Bosque de Chapultepec, Mexico.

1984 "20th Century Photographs from
 Hawaii Collections,"
 Honolulu Academy of Arts, HI.

1983 "Chris Danton, Doug Prince, and Robert
 Rauschenberg," Carl Solway Gallery,
 Cincinnati, OH.

1982 "Harry Callahan, Doug Prince and
 William Clift," Photoworks Gallery,
 Boston, MA.
 "Edouard Boubat and Doug Prince,"
 JEB Gallery, Inc., Providence, RI.
 "Still Modern After All These Years,"
 Chrysler Museum, Norfolk, VA.
 "Humor in Photography," National
 Artist's Alliance, New Haven, CT.

1981 "The First International Photographic
 Exhibition," Leicester Museum,
 Leicester, England; traveling exhibition.

1980 "Photography: Recent Directions,"
 DeCordova Museum, Lincoln, MA.

1979 "Un Autre Relief," Recontres
 Internationales de la Photographie,
 Arles, France.
 Four–Person Show with Bart Parker,
 Jerry Uelsmann, and John Woods,
 Vision Gallery, Boston, MA.

1978 "Mirrors and Windows: American
 Photography since 1960," Museum of
 Modern Art, New York, NY.
 "Collector's Choice," Worchester Art
 Museum, Worchester, MA.

1977 "PhotoSynthesis," Herbert F. Johnson
 Museum of Art, Cornell University,
 Ithaca, NY.

1975 "12 Photographers," Addison Gallery of
 American Art, Andover, MA.

1975 "Artist Biennial," New Orleans Museum
 of Art, New Orleans, LA.

1974 "Ten American Photographers,"
 Photographers' Gallery, London.
 "New Images in Photography,"
 Lowe Art Museum, Miami, FL.

1973 "Light and Lens," Hudson River
 Museum, Yonkers, NY.
 "Extraordinary Realities,"
 Whitney Museum, New York, NY.
 "Children: 1843-1973,"
 Exchange National Bank, Chicago, IL.
 "Contemporary Photographs,"
 Princeton Art Museum, Princeton, NJ.
1970 "Photography Into Sculpture," Museum
 of Modern Art, New York, NY.
 "12 x 12," Museum of Art, RISD,
 Providence, RI.
1968 "Young Photographers," University Art
 Museum, University of New Mexico,
 Albuquerque, NM, toured nationally.
 "Seven Young Talents from Iowa,"
 Richard Feigan Gallery, Chicago, IL.
1965 "Seeing Photographically," George
 Eastman House, Rochester, NY.

❧

SELECTED PERMANENT COLLECTIONS

Museum of Modern Art,
 New York, New York.
National Museum of American Art,
 Smithsonian Institution,
 Washington, D.C.
Art Institute of Chicago,
 Chicago, Illinois.
International Museum of Photography,
 Rochester, New York.
Philadelphia Museum of Art,
 Philadelphia, Pennsylvania.
International Center of Photography,
 New York, New York.
Museum of Fine Arts, RISD,
 Providence, Rhode Island.
Addison Gallery of American Art,
 Andover, Massachusetts.

Princeton Art Museum,
 Princeton, New Jersey.
Museum of Fine Arts, Boston,
 Massachusetts.
Australian National Gallery,
 Canberra, Australia.
Kansas City Art Museum,
 Kansas City, Kansas.
Delaware Art Museum,
 Wilmington, Delaware.
High Museum of Art,
 Atlanta, Georgia.

❧

SELECTED PUBLICATIONS

Photo Sculpture, Doug Prince, The Witkin
 Gallery, New York, NY, 1979. Twelve
 photographs, statement, biographical data.
Darkroom 2, Lustrum Press, New York, 1978.
 Edited by Jain Kelly. Four photographs: p.
 97-109, statement and text.
Photography's Multiple Roles, The Museum of
 Contemporary Photography, Chicago.
 Edited by Denise Miller. Commentary by
 F. David Peat. One photograph p. 185.
Body, edited and commentary by William
 Ewing. Thames and Hudson, London, 1994.
 Three photographs: p. 358, 370-1.
Healing and the Mind, by Bill Moyers,
 Doubleday, New York,
 One photograph: p. 112.
*Flora Photographica: Masterpieces of Flower
 Photography 1835 to the Present*, edited and
 commentary by William Ewing.
 Simon & Schuster, New York, 1991.
 Two photographs: p.153 & 154.
Zoom; S1, "Les Chinois de la Revolution." Paris,
 1989, one print illustrated: "Italian
 Observation #4, 1984," p. 81.

For Kids' Sake, Photographs of Today's Youth,
 Photographic Resource Center, Boston,
 1985 (Exhibition catalogue)p. 10.

TwentiethCentury Photographs from Hawaii
 Collections, Honolulu Academy of Arts,
 1984 (Exhibition catalogue).

The Human Animal, Simon and Schuster,
 New York, 1985, p. 227.

"Illusions of Reality," US Air, New York,
 June 1984, p. 50–55.

"Portfolio of Prints," Mainliner Magazine,
 Vol.26, No.2, n.n.

"Doug Prince," Printletter, No.35 Sept/Oct 1981,
 Vol. 6 No. 5, Zurich, Switzerland.
 Nine photographs: cover, p. 17–24 and
 interview by Gulliana Scime.

American Photography Today, Vision,
 Tokyo Photographic College, 1981.
 Edited by Satoru Fujii. p. 118, 119.

Photography: A Handbook of History, Materials,
 and Processes, Holt, Rinehart & Winston,
 New York, 1980 by C. Swedlund.

Photography Annual 1980, Ziff Davis,
 New York, 1980. Edited by Jim Hugh.
 Six photographs: p. 98–103.

Art Forum, September 1979, New York.
 One photograph: rear inside cover.

The Photography Collector's Guide,
 New York Graphic Society, Boston, 1979,
 by Lee Witkin.

A Ten Year Salute, The Witkin Gallery
 1969–1979, Addison House, Danbury, New
 Hampshire, 1979. One photograph: p. 143.

Mirrors and Windows, American Photography
 since 1960, The Museum of Modern Art,
 New York, 1978.
 Edited by John Szarkowski.
 One photograph: p. 54.

Photo/Synthesis, Herbert F. Johnson Museum of
 Art, Cornell University, Ithaca, New York,
 1976. p. 78.

Object and Image, an Introduction to Photography,
 Prentice Hall, New York, 1975, p. 256,
 statement by George Craven.

Light, Contemporary Photographs,
 Light Gallery, New York, 1976.

Small Planet, Harcourt Brace Jovanovich, Inc.,
 New York, 1974. One photograph:
 "Hippopotamus, 1972."

Light and Lens, Methods of Photography, The
 Hudson River Museum, Yonkers, New
 York, 1973, pp. 22,23.

Artweek "3 Dimensions in Photography,"
 Dec. 18, 1971, p. 9.

12 X 12, Museum of Fine Arts,
 Rhode Island School of Design,
 Providence, Rhode Island, 1970, n.n.

Arts Canada, "Photography into Sculpture,"
 June, n. 144–145, 1970, by Peter Bunnell.
 Six photographs: n.n.

Art in America "Photography and Prints,"
 September–October 1969, New York, by
 Peter Bunnell, One photograph: n.n.

Young Photographers, University Art Museum,
 The University of New Mexico,
 Albuquerque, 1968, p. 35.

❧

SELECTED REVIEWS AND COMMENTARY

"Flora Photographica," Review by Charles
 Hagen, New York Times, July 4, 1993.
"Doug Prince," review of Witkin Gallery exhibit
 by Charles Hagen, Artforum, New York,
 March, 1987.
 "Contemporary Photographers,"
 St. Martins Press, New York, 1982. One
 photograph and survey of past work: n.n.
"Contemporary Photography," Aura, Vol.1, #1,
 February, 1976. Buffalo, New York. p. 24,
 and statement by Richard Link.
"A Young Illusionist," New York Times,
 September 14, 1975. Review of show at
 Light Gallery by Gene Thornton.
"Photography at last becomes an art form,"
 Toronto Globe and Mail, September 20,
 1975, by James Purdie.
"Review of one-person show at Light Gallery,"
 Arts Magazine, March, 1973,
 by William Dyckes.
"The Non–Projected Transparency Image,"
 San Francisco Chronicle, September 20,
 1972. Review by Thomas Albright.
"Photography into Sculpture," Art Week,
 February 26, 1972. Review of show at
 Otis Art Institute Gallery.
"Photography into Sculpture," Art Week,
 December 18, 1971. Review of group show
 at Light Gallery by A.D. Coleman.

Colophon

This book was produced on "desktop" in its entirety by Barry Andersen on a PowerTower 225 with 384 MB RAM, multiple internal hard drives, internal zip and CDR, a 15″ tool monitor, and a 17″ AppleVision main monitor. The original photographs were scanned on an Epson Expression 636 scanner, into Adobe Photoshop 5. All work was done in ColorMatch space. The images were produced as duotones using black and Pantone® 422. Duotone curves were slightly modified from Stephen Johnson's "warm gray 8 bl 1" in the Photoshop files. Proofs were made on an Epson EX printer on Epson Photo Paper. Multiple press tests were run to insure monitor, proof, and print correspondence. A standard FOGRA dot gain curve was used. Doug Prince made final digital adjustments to all scans prior to printing.

The book was set up in Quark Express 3.3 for output to a Heidelberg/Quasar film recorder. Photographs were sent at 300 dpi to produce 150 line screens for photographs. Text was produced at 2540 dpi via Quark. The book was printed on a Solna225 plus two-color press on 115# Utopia Premium blue-white gloss paper. Binding by Grummich, Cincinnati, Ohio.

Typefaces used were Adobe Garamond for body copy and Castellar for titles.

Book design by Robert E. Johnson of Libby Perszyk Kathman in Cincinnati, Ohio. The photographs of the photosculptures were produced by Doug Prince. Photograph of NKU by Joe Ruh

Valuable technical information was obtained from:
Barry Haynes and Wendy Crumpler, *Photoshop 5 Artistry* (Indianapolis, New Riders, 1998)

Stephen Johnson, *Making a Digital Book* (Johnson Photography, Pacifica, CA, 1993)

David Blatner and Bruce Fraser, *Real World Photoshop 5* (Berkeley, CA, Peachpit Press, 1998)

Northern Kentucky University

Northern Kentucky University, the newest of Kentucky's eight state universities, was founded in 1968. Located eight miles south of downtown Cincinnati, Ohio, it currently has an enrollment of approximately 12,000 students. NKU serves its regional residents as well as out-of-state and international students.

The Department of Art has programs in art education, art history, photography, graphic design, ceramics, printmaking, sculpture, painting, and drawing. Over 300 majors are served by 13 full–time faculty and 11 adjunct faculty. Well–equipped facilities offer students a well-rounded education in the visual arts.

For further information contact:

Dr. Donald Kelm, Chair
Department of Art
Northern Kentucky University
Highland Heights, Kentucky 41099
(606) 572-5421
kelmd@nku.edu
http://www.nku.edu/~art/art_home.html
For further information on this exhibition:
http://www.nku.edu/~photo/Prince/